Blackstock's Collections

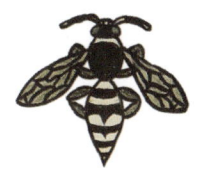

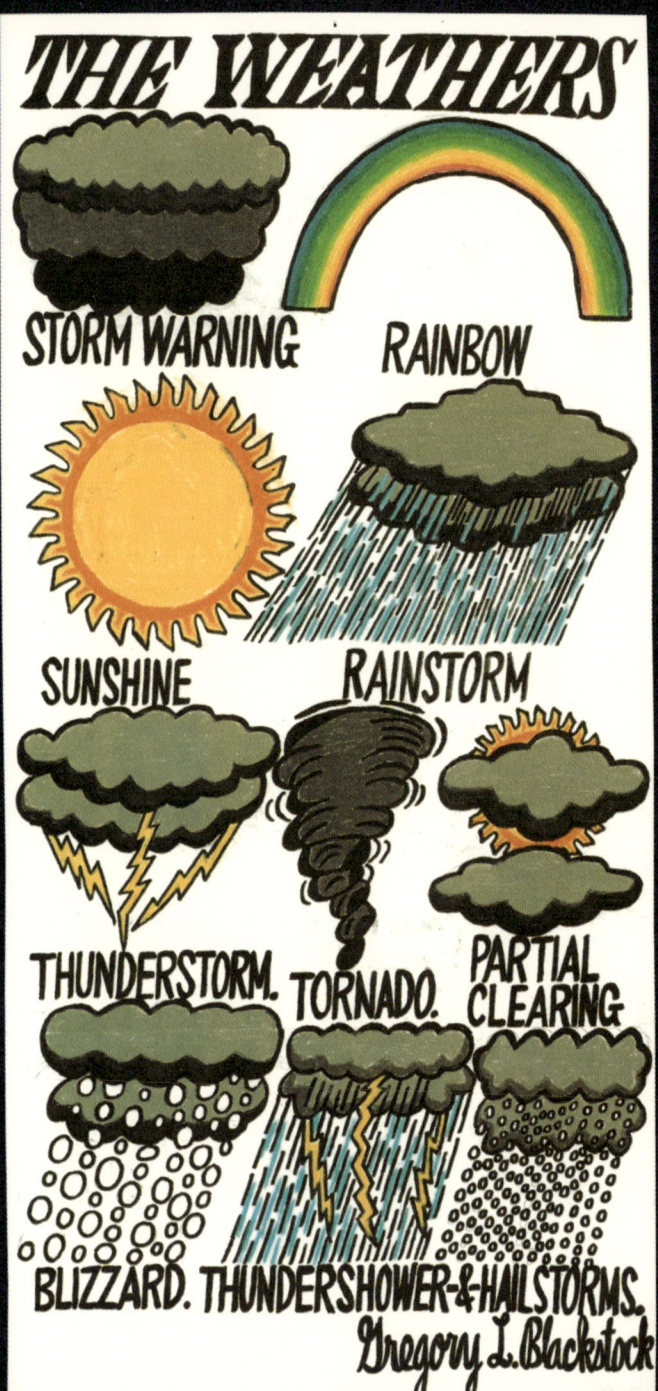

THE WEATHERS
2004 | 25 x 12 inches

THE DRAWINGS OF AN ARTISTIC SAVANT

Blackstock's Collections

GREGORY L. BLACKSTOCK

Foreword by
DAROLD A. TREFFERT, MD

Introduction by
KAREN LIGHT-PIÑA

PRINCETON ARCHITECTURAL PRESS
NEW YORK

Published by
Princeton Architectural Press
37 East Seventh Street
New York, New York 10003

For a free catalog of books, call 1.800.722.6657.
Visit our web site at
www.papress.com.

© 2006 Gregory L. Blackstock
All rights reserved
Printed and bound in China
09 08 07 06 4 3 2 1 First edition

No part of this book may be used or reproduced in any manner without written permission from the publisher, except in the context of reviews. Except where noted, all artwork appears courtesy of Garde Rail Gallery, Seattle.
www.garde-rail.com

Conceived and produced by Tributary Books, Seattle
www.tributarybooks.com

PRODUCER: Kitty Harmon
PHOTOGRAPHY: Jim Fagiolo
EDITING: Clare Jacobson
EDITORIAL ASSISTANCE: Dorothy Ball and Lauren Nelson
DESIGN: Jane Jeszeck, Jigsaw
www.jigsawseattle.com

For their highly valued contributions, Tributary Books is indebted to Dorothy Frisch, Karen Light-Piña, Dr. Darold Treffert, and, most of all, Gregory L. Blackstock.

Princeton Architectural Press extends special thanks to: Nettie Aljian, Nicola Bednarek, Janet Behning, Becca Casbon, Penny (Yuen Pik) Chu, Russell Fernandez, Peter Fitzpatrick, Jan Haux, John King, Mark Lamster, Nancy Eklund Later, Linda Lee, Katharine Myers, Scott Tennent, Jennifer Thompson, Paul Wagner, Joseph Weston, and Deb Wood.
—Kevin C. Lippert, publisher

LIBRARY OF CONGRESS CATALOGING-IN-PUBLICATION DATA
Blackstock, Gregory L. (Gregory Lyons), 1946-
 Blackstock's collections : the drawings of an artistic savant / Gregory L. Blackstock ; foreword by Darold A. Treffert ; introduction by Karen Light-Piña.
 p. cm.
 ISBN-13: 978-1-56898-579-4
 ISBN-10: 1-56898-579-7
 1. Blackstock, Gregory L. (Gregory Lyons), 1946- —Catalogs.
 2. Autistic artists—Washington (State)—Seattle—Catalogs.
 3. Savants (Savant syndrome)—Washington (State)—Seattle.
 I. Title.
 NC139.B52A4 2006
 741.973—dc22
 2006001273

NOTE: All of Gregory Blackstock's drawings are created with graphite, marker, and crayon on paper.

THE INKY DEPTHS FISHES
Nature's Lit-Up Creatures of the Deep Ocean

- LANTERNFISH
- VIPERFISH
- COMMON DEEP-SEA ANGLER FISH
- HATCHET-FISH

Gregory L. Blackstock

CONTENTS

FOREWORD 9
Darold A. Treffert, MD

BIOGRAPHY 13
Gregory L. Blackstock

INTRODUCTION 17
Karen Light-Piña

OUR FAMOUS BIRDS
 The Great American Owls 22
 The Great World Eagles 24
 The Great World Crows 25
 The Great Italian Roosters 26
 The Great Turkeys 27
 The North American State Birds 28

FISH & THE LIKE
 Monsters of the Deep 30
 The Salmon 32
 The Mackerels 33

THE DOGS
 The Gleaming Chows 34
 The Airedale Terriers 36
 The Collies 37
 The German Shepherd Police Dogs 38
 The Scottish Terriers 39

INSECTS & ARACHNIDS
 The Dangerous Arachnids 40
 The Great American Wasps 42
 The Bees 43
 The Colorful King-Size Swallowtail Butterflies of the World 44
 The Great World Jungle Butterflies 45
 The Ants of the Americas 46
 The Major Forestry Pests 47

THE PLANTS
 The Poinsettias 48
 The Carnivorous Plants 50
 Our Famous Tropical Fruits 51
 The Berries 52
 The Nuts 53
 The Famous Composite Family Garden Flowers 54
 The Great Cabbage Family 55

THE TOOLS
 The Hatchets 56
 The Miscellaneous Tools 58
 The Saws 60
 The Hammers 61
 The Files 62
 The Drills 63
 The Knives 64
 The Shears 65
 The Spatulas 66
 The Trowels 67
 The Hoes 68
 The Housekeeping Tools 69

THE NOISEMAKERS
 The Alarms 70
 The Stringed Musical Instruments 72
 The Pianos 73
 The Noisemakers 74
 The Drums 76
 The Bells 77

THE VEHICLES
 The Patrol Vans 78
 The Family Moving Trucks 80
 The Iraqi War Tanks 80
 The Emergency Trucks 81
 Our Old-Time Freight Train Equipment 82
 The Race Cars 83
 Our Famous Antique Cars 84
 The Law & Order Authority Vans 85

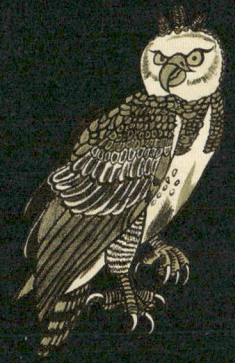

AVIATION COLLECTION
 The Convair-Liners 86
 The World War 2 British
 Bombers 88
 Our Famous World War 2 Ally
 Fighters Complete 89
 The Golden Age of Historic United
 Air Liners 90
 The Historic Americas
 Turboliners 91
 The Early Boeing Jet Planes 92
 The Big Jets 93
 The World War 2 U.S. Bombers 94
 The World War 2 Messerschmitt
 German Fighter Planes
 Complete 95

BOATING & SEAMANSHIP
 The Historic D Outboard Raceboat
 Equipment 96
 The Historic F Outboard Raceboat
 Equipment 98
 Our Early Unlimited Inboard
 Hydroplanes 99
 The Simple Knotting 100
 The Easy Single Ornamental
 Sheepshanks 101
 Scouting & Seamanship
 Sheepshanks 102
 The Buoys 103

ARCHITECTURAL COLLECTION
 The Oriental Temples 104
 The Roofs 106
 The Tents 107
 The Barns 108
 The U.S. President Memorials 110
 The Historic American Homes 111
 Our State Lighthouses 112
 The World Landmark Towers 113
 The Vacationers' Irish Castles 114
 Our State's King-Size Jails 115
 The Historic Intercontinental
 Homes 116
 The Great Greek Temples 118
 The Historic Roman Temples 119

THE THINGS TO WEAR
 The Hats 120
 The Shoes 122
 20 of Our North American
 Men's Major League
 Baseball Uniforms 124
 The Masks 125

THE LAST BUT NOT LEAST
 The Crosses 126
 Monsters of the Past 128
 The World's Dangerous
 Pit-Vipers 129
 The Kites 130
 The Balls 131
 The Classical Clowns 132
 The Great American Presidents 133
 The Irish Joys 134
 Crayola Watercolors 136
 Crayola Crayons 136
 The Art Supplies 137
 The Christmas Trappings 138
 The Skiers 139
 The Baskets 140
 Colorful Egg Pattern Favorites
 to Go For 141
 More Colorful Egg Pattern Favorites
 to Go For 142

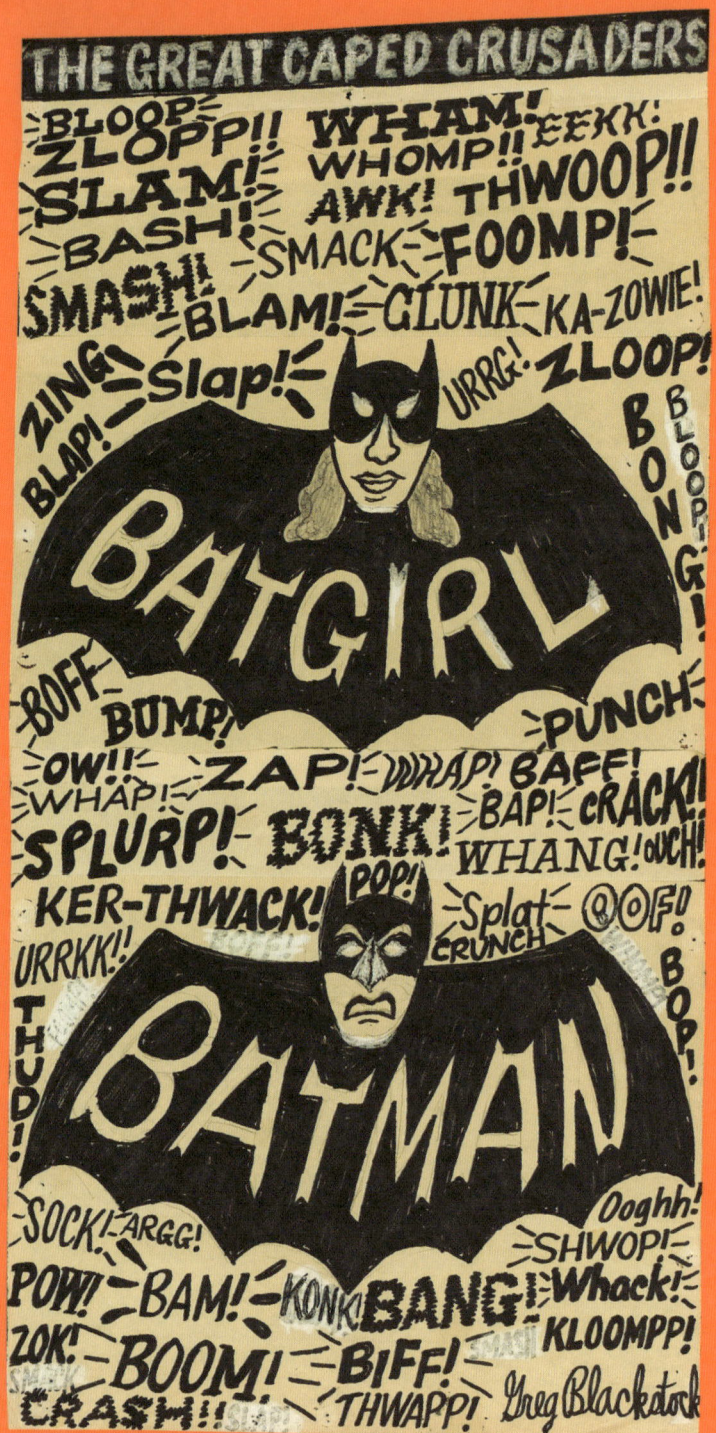

THE GREAT CAPED CRUSADERS
1989 | 21.5 x 11 inches

FOREWORD
Darold A. Treffert, MD

A "GIFT OF DRAWING" IS A TERM FIRST USED in describing the artistic savant nearly a century ago. In 1914, Dr. Alfred Tredgold wrote in detail about the extraordinary artistic, musical, mathematical, and mechanical abilities that so regularly characterized cases of what we now call Savant Syndrome. These savant skills are always accompanied by a marvelous memory. It is evident from descriptions of him and from viewing his artwork that Gregory L. Blackstock has this gift of drawing, and fortunately for us all he has used the gift to produce a body of work that will be of great interest to many.

Savant Syndrome—a remarkable condition in which persons with autism or other developmental or central nervous system disorders have some extraordinary island of genius or ability that stands in stark contrast to their overall limitations—is quite rare. Only about one in ten autistic persons has such spectacular skills, and only about one in fifteen hundred persons with other developmental disorders or other central nervous system disorders possesses these special abilities. Within Savant Syndrome artistic ability is not the most common skill; that distinction belongs to musical talent, followed by calendar calculating and other numerical or mathematical abilities. Whatever the savant skill, however, it is always linked with prodigious memory, typically very visual and exceedingly deep, although very narrow within the confines of the interest or ability. What one sees in Gregory L. Blackstock, then, is a rare artistic talent in an already rare condition.

Blackstock shows those characteristic traits that constitute Savant Syndrome: an extraordinary skill coupled with outstanding memory grafted onto some underlying disability. But while all savants share that basic matrix, each savant is also unique, and that certainly is the case with Blackstock. First of all, his meticulously drawn lists of all sorts of items are,

as an artistic format, inimitable. Second, most savants have skills in only one area of expertise, such as art, music, or mathematics—spectacular as those skills might be. But Blackstock has several areas of special skills, a somewhat unusual circumstance among savants.

With his musical and linguistic abilities Blackstock has accumulated a repertoire of hundreds of songs and at least the rudiments of twelve languages. But it is in art that his expertise excels. His drawings show the precision of a Swiss watchmaker coupled with the wide-range musing of a philosopher. A writer reviewing his artwork for a Seattle newspaper aptly referred to Blackstock, with his obsessive lists of all sorts of everyday items, as an "anthropologist of the everyday." Most of the visual lists are extensive and inclusive. *The Miscellaneous Tools*, for example, includes sixty-six separate items—pliers, augers, chisels, tack claws, burnishers, broach skewers, and some tools I have never heard of—carefully placed and meticulously drawn on a page worthy of any tool catalog. Like other artistic savants, he draws from memory; having seen an item once is enough. That image goes on his internal hard drive to be retrieved, and then reproduced, whenever he is ready to combine it on paper with a host of other, similar (at least in his mind) and similarly stored and retrieved images.

Savant skills are as much a force as a gift. The musician must play; the sculptor must sculpt; the mathematician must compute; and the artist must draw. But these are more than frivolous compulsive outpourings. They are the language of the savant, in some cases the sole communication with the rest of us. They are also, in all cases, the "work" of the savant, the activity that is what they do and what they are good at. It is their world intersecting with ours. Like most people, savants value their work, and we are its beneficiaries as well. By training the talent and reinforcing the ability that surfaces so conspicuously and marvelously in savants, the skills can be used to minimize the disability of the savant by providing a useful conduit for increased language acquisition, enhanced socialization, and improved daily living skills.

To his credit, Blackstock has been largely self-sufficient through his conscientious employment as a pot washer. Coworkers appreciated his artwork and gave him welcome recognition through publication of his drawings in the employee newsletter. Then came the gallery exhibitions, and now this book. Like so many of the rest of us whose work is a passion as much as a form of employment, Blackstock is likely to be busier than ever now that he is in "retirement," with even more time to pursue his love of music and art.

The argument rages as to whether the savant is a genius because of his handicap, or in spite of it. Some of both ideas are true. Unique circuitry does allow the savant to tap into some reservoir of hidden skill that may lie within us all, and clearly artistic or musical genius exists within the savant in its own forceful right. Gregory L. Blackstock would have been a gifted artist even without his handicap. The fact that his ability surfaces in such great measure in spite of his handicap is amazing. But lying within him, without doubt, is some inborn talent. That his mother was a portrait artist points to this, to be sure. His inherited talent melds with a hardwired knowledge of the vast syntax and "rules" of art, which all artistic savants seem to have. The result is something I call "genetic memory," part of the marvelous equation of savantism.

Savant Syndrome, then, is a three-legged stool. It combines idiosyncratic circuits and genetic memory, intense motivation and practice, and a supportive and loving family and/or caretakers who value the savant not just for what he or she does, but also for whom he or she is. In Blackstock's case, his extended family, his coworkers, his church community, and now recognition for his artistic output all contribute to his well-being. We ought not underestimate the importance of a supportive and caring network that values not just the skills and the mind of the savant, but seeks to better understand and enrich the experience and world of the savant as well.

Savants are geniuses who live among us; they hint at genius that might lie within us. Artistic savants have brightened our world with their skills—their drawings, their music, their sculptures. They have taught us something else, as well—that great gifts and talent can coexist with disease and defect, that focusing on strengths and abilities is more important than resigning to weaknesses or disability, that labels confine but belief propels, and that unconditional love may be an unstoppable remedy for untoward circumstances.

Darold A. Treffert, MD, past president of the Wisconsin Medical Society and psychiatrist at St. Agnes Hospital in Fond du Lac, Wisconsin, has studied Savant Syndrome for forty-three years. He was a consultant to the film Rain Man *and is the author of* Extraordinary People: Understanding Savant Syndrome. *On his web site, www.savantsyndrome.com, Treffert describes the condition, reviews and summarizes the world literature on this topic, catalogs and categorizes savant abilities, and offers profiles of Savant Syndrome patients.*

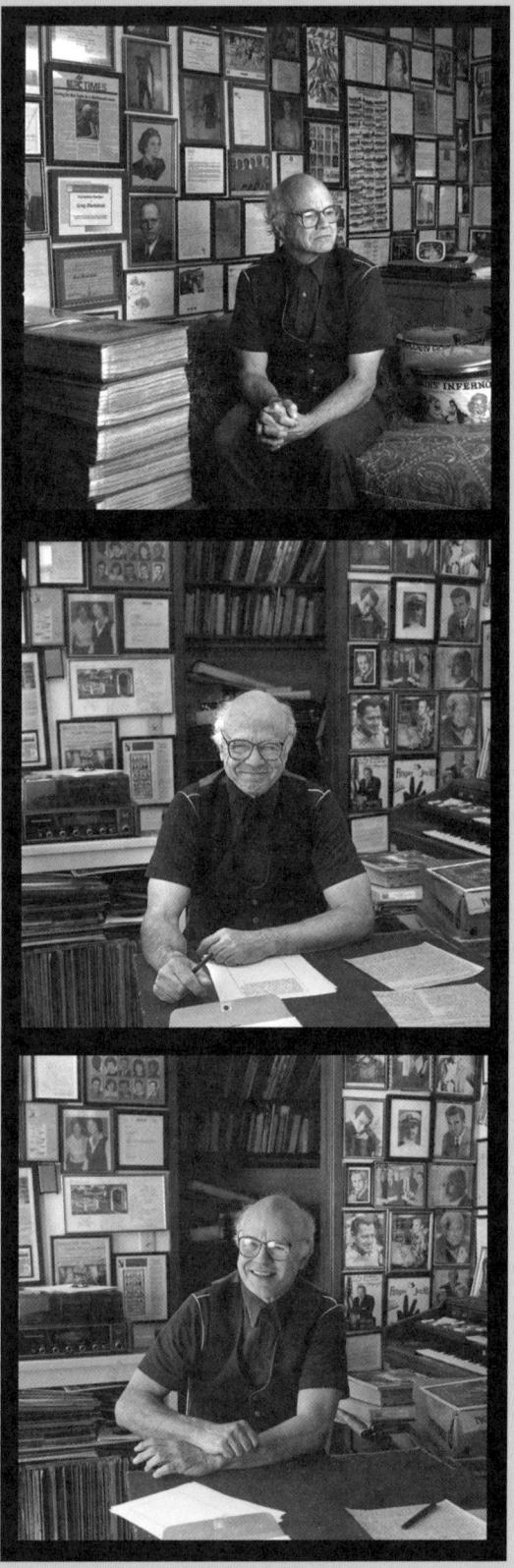

Gregory L. Blackstock at home, November 2005

MY BIOGRAPHY

1. **MY DATE OF BIRTH IS:** January 9th, 1946
2. **MY PREVIOUS SCHOOLS OF 1950 TO 1964** are Lake Forest Park's Graelson Nursery School, Helen Bush Kindergarten School, Old Greenlake Elementary School, Latona Elementary School, Santa Barbara California's Devereux Ranch School, Applegate California's Holly Acres Training Incorporated School and Central Seattle Community's Pacific Prevocational School.
3. **MY USUAL CITY NEWSPAPER ROUTE PERIOD** as Seattle Post Intelligencer Junior Dealer from September 3rd of 1964 through entire March 1967 in which I have been awarded with a $25.00 U.S. Savings Bond on July 26th, 1966 — absolutely during my double route delivery in the Windermere area of northeast Seattle where I lived at that time.
4. **THE DAY OF MY FIRST ACCORDION** in which my dad got for me in the summer of 1963.
5. **MY FIRST DRAWING PUBLISHED IN THE NEWSPAPER.** My own original Batman cartoon drawing with all the sound-effect words accompanying his battle with underworld characters.
6. **MY PREVIOUS JOBS OF 1968-TO-2001** are the Temco Incorporated food canning manufacturing plant as janitor, Meet-a-Need Flour Sifter Manufacturing Company, Seattle-Tacoma Airport Hyatt House Hotel and Washington Athletic Club in downtown Seattle, finally — in which I worked as pot-&-dishroom steward from September 9th of 1975 through January 12th of 2001 and won the "Alberta Nash" award among the club's team members that meant they served 25 years and longer.
7. **MY FATHER'S PASSING** — October 14th, 1973.
8. **MY MOTHER'S PASSING** — August 25, 1999.
9. **MY FIRST GARDE-RAIL GALLERY ART SHOW,** which was held on Friday February 6th of 2004.
10. **BEST INDIVIDUAL BOWLING SCORE** is 300 which was for open play practice only at the University Village Bowling Lanes. But most important of all — compared to my antique immediate California Devereux School's main hall track-&-field event of Mayday 1959 with my overall championship was absolutely Channel 11's Pin Busters Bowling Television Program at Sunset over in Ballard where I also won the victory over a high school individual named Tony Lewis on Saint Patrick's Day Saturday of 1962 during my first year at Pacific Prevocational School that I represented.

Among my school teachers and overall authorities, the real praise from schoolmates I had were Eddie Coester of Mr.

Terry's boys gymnasium class, ukulele-&-guitar individual John Neff and afro-American rock music piano player Frank Morris, Jr. of Mr. Affleck's jazz instrumental boys class, and Mr. Harley Yates of Miss Brehman's-&-Mr. Chapel, Senior's academics I've known originally from Mr. Fine's auto shop boys class, especially after I won the Pin Busters Bowling Trophy towards the end of the school year.

Also among the others, I showed it to visiting-&-departing girls' club officers Sandra Hughes and Donna Klatt while attending Mrs. Lough's art class right at that time before school was out. I also presented my trophy to Kevin Connors, David Sattler, Bill Leishman's younger brother Michael, David Smith's twin brother Steven, David Haugen and Sally Gray's fellow fiancee Edward Holmes at 4th Avenue and Union Street downtown — on my way home from school, altogether to their great amazement on that Graduation Day of June 5th, 1962.

I would like to say, ladies-&-gentlemen, that bowling on "Pin Busters" TV show was undoubtedly the very finest athletic history I've ever had in which I will absolutely <u>never</u> forget as long as I live — even in the future.

11. <u>NAMES OF THE PLACES I HAVE BEEN TO FOR VACATION, 1977-2005</u>
1. Bluestone Lake Dam's Professional Outboard National Boat Race — 4 miles uphill from Hinton, West Virginia.
2. Braunig Lake, Texas Professional Outboard National Boat Race — east of the Alamo City, San Antonio.
3. More of California's Devereux School and Disneyland.
4. Newport, Tennessee with my immediate family, for a visit with Dad's own maternal relationships.
5. 6-Flags Magic Mountain Theme Park, Norwalk Golf-&-Stuff Family Fun Center, and Paramount's Great America Amusement Park, California. And finally the Los Angeles County Fair in Pomona.
6. Wyoming for visits to the Yellowstone National Park and the huge Cheyenne Frontier Days Rodeo Opening Fair.
7. LaCrosse, Wisconsin Professional Outboard National Boat Race.
8. Kansas City, Missouri World's-of-Fun Amusement Park.
9. Ohio's Cedar Point Fun Resort, "The Beach" Water Park, Kings Island Family Entertainment Center, Cincinnati Zoo, Geauga Lake Funtime Park, and the state's Ohio Sea World.
10. Montana's Glacier National Park, West Yellowstone Town, Bozeman, Flathead Lake, Whitefish, Kalispell, Northwestern Montana Fair and the Billings Montana Fair.
11. California's Lake Ming Professional Outboard National Boat Race, Knott's Berry Farm, Lion Country Safari, Castle Amusement Park, Anaheim's Camelot-&-Golf-&-Stuff Family Fun Centers, Queen Mary and Spruce Goose, Santa Barbara, Goleta, Santa Cruz Seaside Company Beach Boardwalk, New Walt Disney California Adventure, Old-&-New Marine World Africa Parks, San Diego County City Fair and Wild Animal Park & Zoo,

Sacramento and San Francisco.
12. California's Redwood, Sequoia, King's Canyon and Yosemite National Parks.
13. Reno Rodeo Opening Fair Parade, Nevada.
14. Our State's Mount Rainier & Olympic National Parks, Anacortes and Port Angeles.
15. Illinois's 6-Flags Great America Theme Park and Modified National Outboard Race in Centralia at Raccoon Lake Park.
16. New 6-Flags Fiesta Texas Theme Park, 6-Flags Astroworld in Houston, the Big 6-Flags Over Texas in Arlington, Fort Worth Livestock Rodeo Fair Parade and Dallas — also for the Great Texas State Fair in North America.
17. Oklahoma City Zoo, Oklahoma State Fair, Tulsa State Fair.
18. Oregon State Fair in Salem, Lane County Fair in Eugene, Crater Lake National Park and Portland.
19. Canada's Vancouver & Victoria, B.C. and Abbotsford International Airshow; also Edmonton, Jasper—Banff & Waterton Lakes National Parks altogether in Alberta.
20. Colorado's old Elitch Gardens and Lakeside Amusement Parks and Zoo altogether in Denver, and Pueblo's great big Colorado State Fair Jubilee.
21. Acadia National Park, Maine.
22. Hot Springs National Park Town, Arkansas.
23. Salt Lake City, Ogden and Farmington's Lagoon Amusement Park in Utah altogether.
24. New Jersey's 6-Flags Great Adventure Theme Park in Jackson.
25. Idaho's Pend O'Reille Outboard Regatta, and Boise Christmas Holidaytime Parade.
26. The great big Eastern United States Expositional Fair in West Springfield, Massachusetts.
27. Minnesota's Knott's Camp Snoopy and Valleyfair Amusement Parks, and its state Fair in Saint Paul.
28. Vermont's Lake Champlain Valley and State Fairs, Burlington Community and Lakefront, and the state's leading sugar maple grove farms and industry town of Saint Johnsbury.
22. Florida's Walt Disney World Theme Parks, and its Ringling Brothers and Barnum & Bailey Circus World Park.

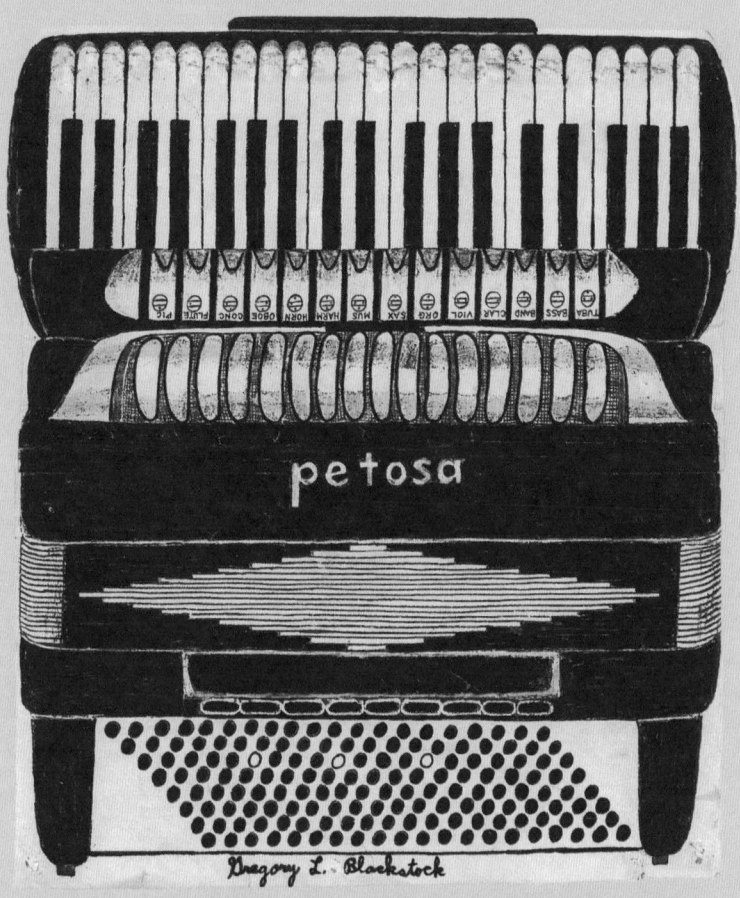

PETOSA (THE ACCORDION)
1986 | 20 x 18 inches
Collection of Greg Kucera and Larry Yocom

INTRODUCTION
Karen Light-Piña, Garde Rail Gallery

AT AGE FIFTY-EIGHT, GREGORY L. BLACKSTOCK began a new and exciting chapter in his life. The retired pot washer walked into Seattle's Garde Rail Gallery to attend the opening of a solo exhibition of the drawings he had made over the past eighteen years, the results of a consuming pastime relatively few people knew about. Beaming with accomplishment and self-esteem, he introduced himself to complete strangers, escorted them to pieces of his work, and urged them to read a newspaper review of the show posted on the wall beside his biography.

As his art began to sell, Blackstock became caught up in the excitement. "Do you think I'll be a world-famous artist with all of the old Hollywood film stars, like Doris Day, beautiful ageless freckly blonde, and Dustin Hoffman, and people in other countries all over the world?" he wondered. "Do you think that people would like to buy my own original drawing of *Our State's King-Size Jails*? How about my *Early Boeing Jet Planes*?" he asked, followed by propeller sound effects and a finger whirling in front of his nose as if he were an airplane about to descend.

In the middle of the evening Blackstock got out his Petosa accordion and sat down on the case as if he were playing for change on any Seattle sidewalk. His forearms noticeably developed from years of hauling and playing, he started hammering out "Stars and Stripes Forever," surrounded by a panoramic view of his unique drawings and a full house of happy and admiring well-wishers. It was the highlight of an unforgettable evening.

OPENING NIGHT WAS ESPECIALLY POIGNANT for Blackstock's cousin, Dorothy Frisch. She had seen the value in the artwork he had been creating for so many years, both as a potential source of income for him in his retirement and as a means of his connecting with others. She sent

samples of his drawings to me and my partner, Marcus Piña, in 2003. We were intrigued immediately by Blackstock's story and his art and made plans to meet him.

The focus of our Garde Rail Gallery is self-taught artists and their work—in particular, southern folk art and what is known as Outsider Art. The field experienced a large boom in the 1980s and into the 1990s, with major institutions and collectors adding works to their collections. Several books were published on the topic, and a great amount of work was put into legitimizing the art, its artists, and the field. News of the latest-discovered artist was quickly communicated throughout the community of devotees, and work was snapped up. Today, with greater exposure via the Web, works by Outsider artists are accessible to a broader audience, but a fast-disappearing rural America means that fewer self-taught artists are emerging. The availability of unique and unexposed work has decreased steadily over the past ten years; now it is rare to find a true Outsider. Yet here in our own city we were being introduced to Gregory L. Blackstock, a graphic artist unaffected by mainstream society due to living on its periphery his entire life.

Knowing that Blackstock was autistic, my partner and I were unsure about how comfortable he would be meeting and talking with us, let alone showing us his drawings. Frisch agreed to accompany us to make sure he was at ease. As we arrived at his apartment, he met us with affirming embraces and a smiling and resounding "Hello!" He was eager to welcome us into his world, and there was plenty to absorb. The walls of his studio apartment were covered, floor to ceiling, with tidy rows of frames—perfectly arranged, like the images in his drawings—containing photos of old Hollywood film stars, letters from public figures, newspaper articles, and family memorabilia. Several accordions and a small organ were wedged in corners of the room. On a nearby chair sat a giant stock pot overflowing with crayons, pencils (both graphite and colored), and plenty of black Sharpie markers.

Blackstock pulled a giant bundle of drawings from his closet and flopped it onto the bed in the middle of his studio apartment. As he untied the roll, yellowed on the outside and thick with drawings, I realized that we would be there for some time. He revealed eighteen years of work, some of it for the first time. It felt like Christmas morning.

Blackstock flipped through the drawings so naturally and roughly it made me a little nervous. Many of them were pieced together; the artist had carefully joined varying sizes of paper with glue, sometimes to edit

out parts of his work and start again, other times to create a larger canvas. Most seams were nearly flawless, some not at all discreet. The pieces ranged from a small drawing with only two examples (*Great American Presidents*) up to a large sheet featuring sixty-three items (*The Bells*), with many sizes in between.

The more we saw, the more familiar Blackstock's graphic lists became, yet they remained strange, lovely, sometimes humorous, always specific. Their formality suggests educational charts or pages torn from a distinctive taxonomical guide. The title of each drawing appears at the top in Blackstock's handwritten type. He invents some "fonts" for specific topics—for example, the letters in *The Buoys* float up and down above the subtitle, "Aquatic Warning Guides"; each letter in *The Roofs* contains tiny shingles; and the letters in the title of *The Inky Depths Fishes* are as wavy and shimmery as the inky depths and fishes themselves. All pieces bear Gregory L. Blackstock's signature in his neat, upright script.

His remarkable memory serves Blackstock well as he renders images on paper with pencil, marker, and crayons. I commented on how many tiny differences there were in the teeth from one saw blade to the next in his piece *The Saws*. He replied, in a somewhat frustrated tone, that it took him two visits to Home Depot to memorize them all. He uses no straightedge ("No need," he says) yet his layout is impeccable. And if asked, he can reproduce the same images exactly, time and again—a skill essential to cartooning or illustration, professions in which Blackstock might have excelled under different circumstances.

Here, then, was the work of a self-taught artist completely external to the commercial art establishment, a true Outsider. Blackstock's story is not unlike many of the artists associated with the genre. But unlike the work of most Outsiders, his conveys no emotion; nor does he depict a personal fantasy world, as have well-known Outsider artists such as Henry Darger and Morton Bartlett. Blackstock is not gripped by a divine calling or controversial conceptions. He seems to use his medium to create a personal filing system for clustering and storing the things of the world, both natural and man-made. It appears he finds it useful to compartmentalize that which most of us take for granted.

The creation of order in Blackstock's drawings is solid, direct, and comforting rather than baffling. It may give him a sort of empowerment to methodically draw and shade the frightening and the factual. Or, possibly, he has a depth of focus that compels him to know each topic to its limits. Where another artist might depict a bird or a plane, Blackstock is curious

about all of the birds and all of the planes. Whatever his driving force, his clear voice manifests itself through these visual collections. Looking at them reminds us just how many things in the world there are to know and how many things we have to learn.

AUTISTIC SAVANTS HAVE PRODIGIOUS ABILITIES, but these are commonly accompanied by social limitations and a tendency toward withdrawal—or so we commonly learn. Yet Blackstock expresses himself in ways that enable him to reach out to people wherever he goes. His unique form of verbal communication is large, loud, and impressive, and his repertoire of sound effects astounding. His aural approximation of sitting in the dentist's chair, for example—with a high-frequency drill and tube suctioning—is enough to make your jaw clamp shut involuntarily.

Many of the things that Blackstock likes are noisy—the accordion, organ, television (up to full volume); airplanes, trains, and outboard motor race boats; bells and alarms. You can almost hear the soundtrack accompanying many of his drawings. For years he has played the accordion outside sports stadiums and performance halls, saving his earnings for out-of-town trips. He travels frequently, on his own, to amusement parks and fairs all over the country. He returns from each trip with about twenty-five rolls of film of roller coasters and tilt-a-whirls, local scenery, and other people on vacation. Blackstock is not one to retreat from the world.

His ability to teach himself art and music is astounding. In addition, he has learned conversational Czech, German, and even Tagalog, along with nine other languages, from recordings and from listening to foreign-born coworkers. He not only speaks Russian, but can read and write the Cyrillic alphabet. Native speakers claim his accents are perfect, and he grasps grammatical structures despite little interest in becoming fluent. He can do a perfect imitation of any number of movie scenes and can recite the dialogue of *Pillow Talk* and other favorite films from beginning to end, along with the credits; ask him who the lead grip or the gaffer was and his answer comes without hesitation. Before he became immersed in drawing, one of his favorite ways to amuse himself was to write out the music of songs he heard years ago, note by note but in a new key, on perfectly aligned staffs drawn in freehand.

What is less noted but every bit as remarkable are Blackstock's accomplishments as a member of his community, despite his autism. He has worked since the age of eighteen and has lived independently for

many years, without assistance from any social service agency. He has had much encouragement from a church group, Bridge Ministries, and in particular from Mary Galvin, a minister who organized a "circle of friends" that meets quarterly to offer him support. Greg is responsible for all of his own finances, transportation, entertainment, and apartment maintenance. He is especially proud of the meals he prepares and has created a recipe book of unusual dishes, mostly soups (see inside of covers for examples). In 2001 he retired from a job he held for just over twenty-five years, that of pot scrubber and dish steward for Seattle's Washington Athletic Club. More than a hundred coworkers (some of whom had retired long ago) and acquaintances attended his send-off party. Since then he has had more time for drawing and enjoying the newfound fame he so relishes.

His artistic efforts are at least somewhat propelled by the attention he receives, so contrary to most cases of autism. Now, with a second solo exhibition behind us and Blackstock producing new work for a third, any questions I once had about his adapting to the commerce and publicity of gallery representation have been dispelled. With each sale he is as gratified as with the very first—not because of the money he receives as much as, seemingly, a satisfying conclusiveness. Another drawing has gone out into the world and is checked off his internal list; one can almost imagine him drafting a new collection comprising the drawings that have sold, their usefulness now complete.

Knowing and working with Blackstock has been the high point of our gallery's existence. The effect of his drawings, and his story, on those who come to the gallery is always a pleasure to witness. He continues to inspire those who discover the raw and unfiltered talent he so generously shares.

Karen Light-Piña was raised in Atlanta, Georgia, and now resides in Seattle. With her husband, she founded Garde Rail Gallery in 1998. Garde Rail is the only gallery in the Pacific Northwest dedicated to contemporary folk, Outsider, and self-taught art.

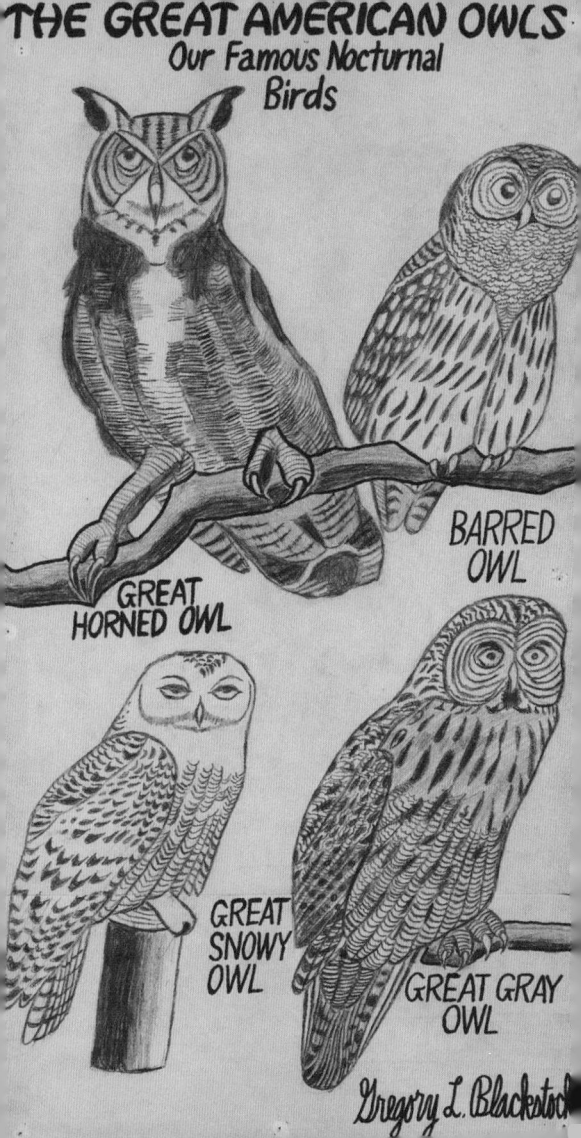

Our Famous Birds

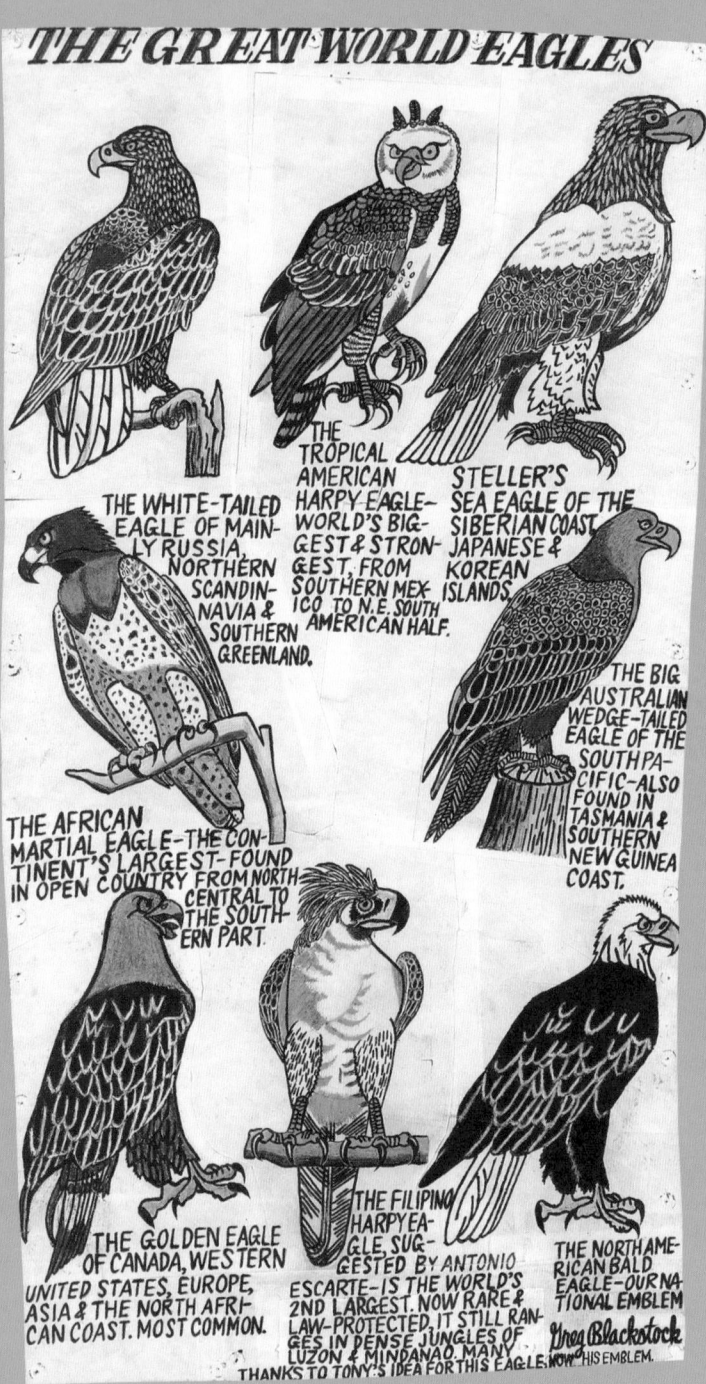

THE GREAT WORLD EAGLES

1993 | 31 x 17 inches
Collection of Michael Longyear

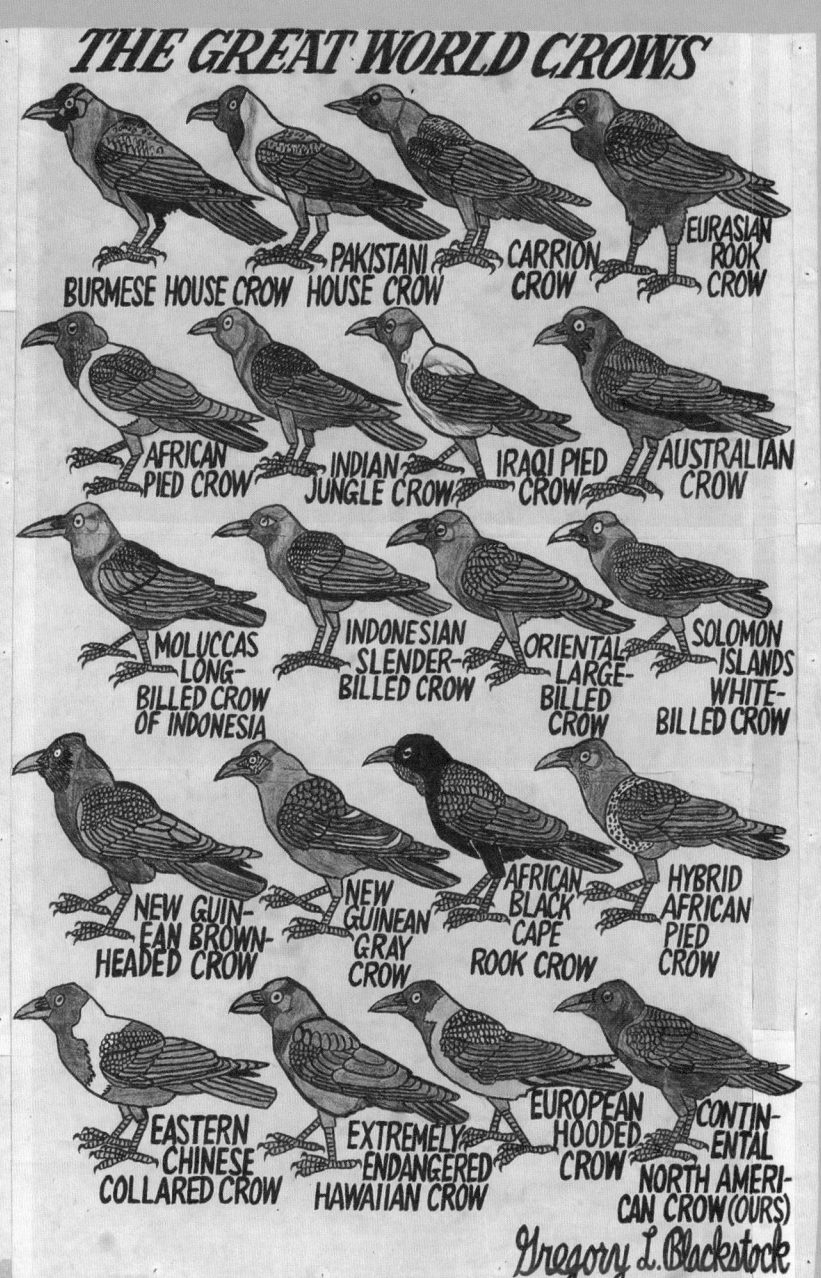

THE GREAT WORLD CROWS

1994 | 31 x 22 inches
Collection of John Buck and Deborah Butterfield

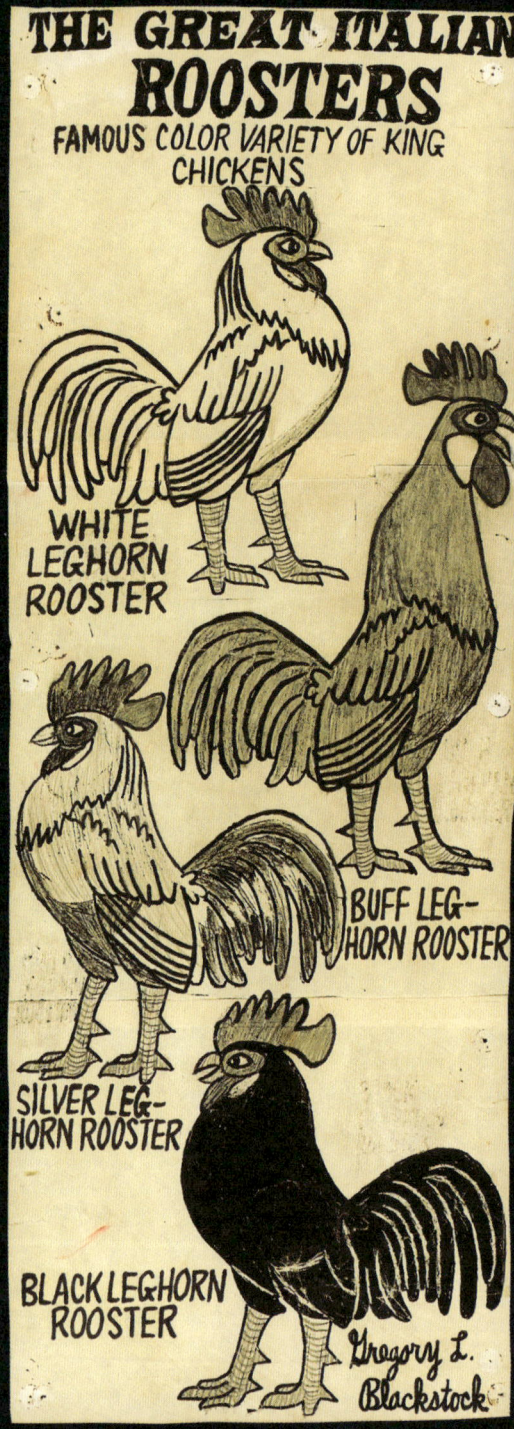

THE GREAT ITALIAN ROOSTERS

1990 | 12 x 9 inches
Collection of Michael Longyear

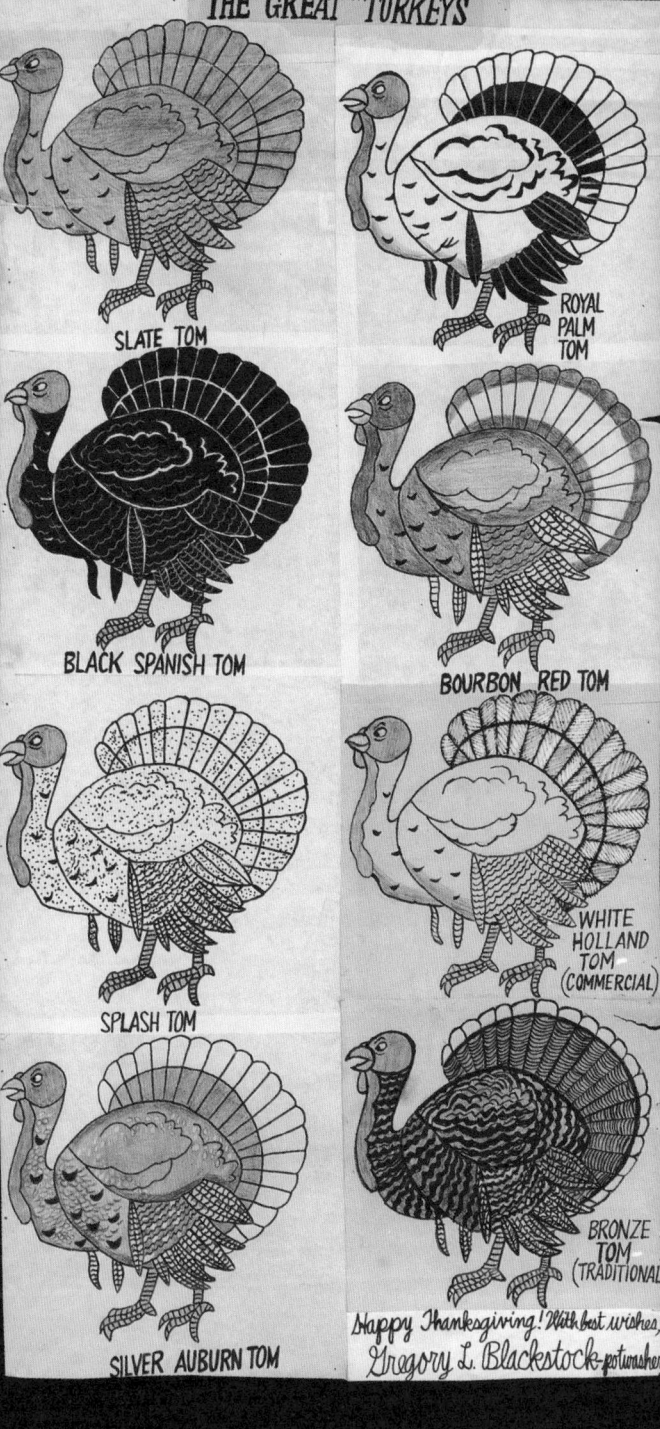

THE GREAT TURKEYS

1994 | 45 x 22 inches

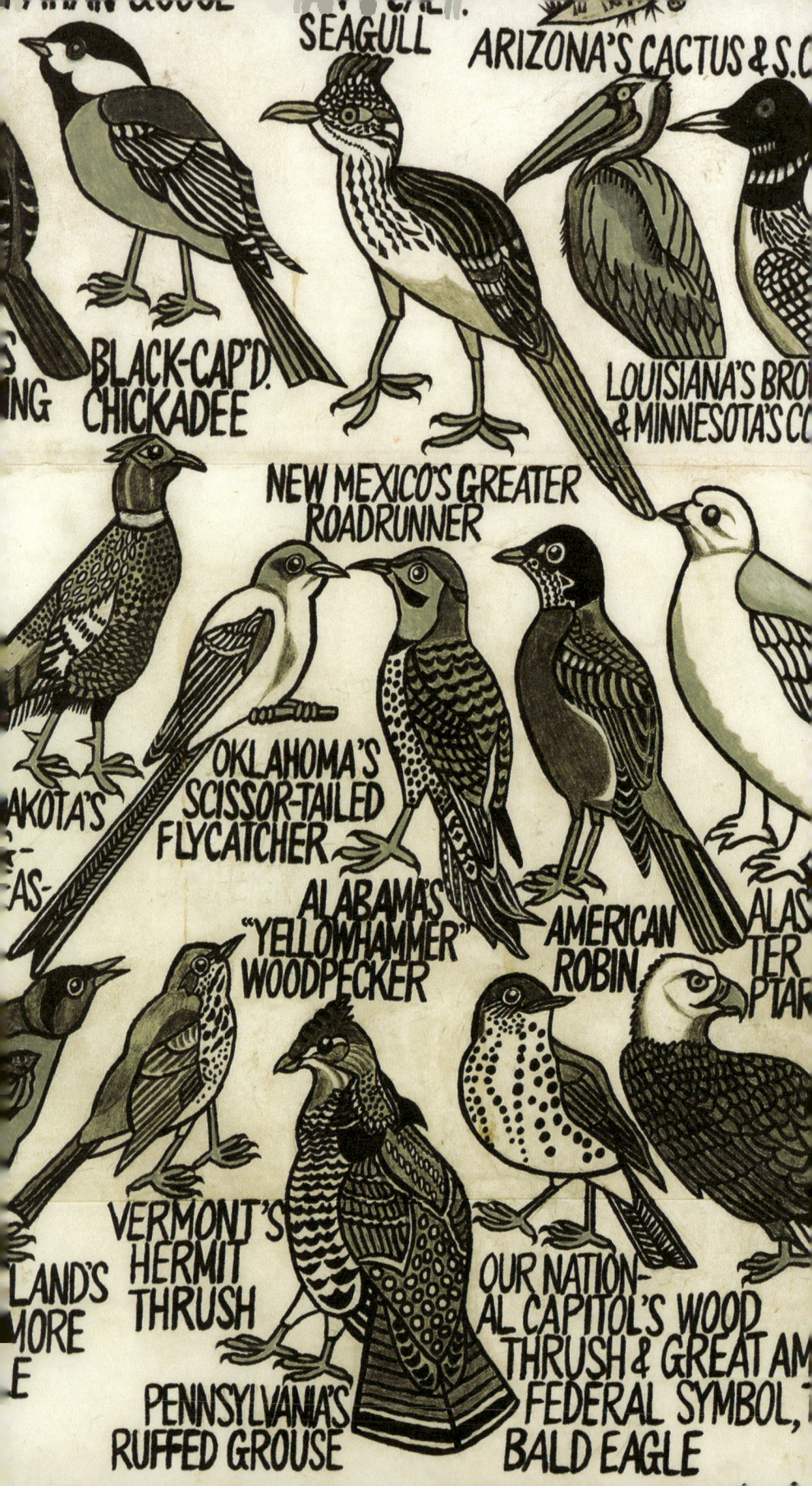

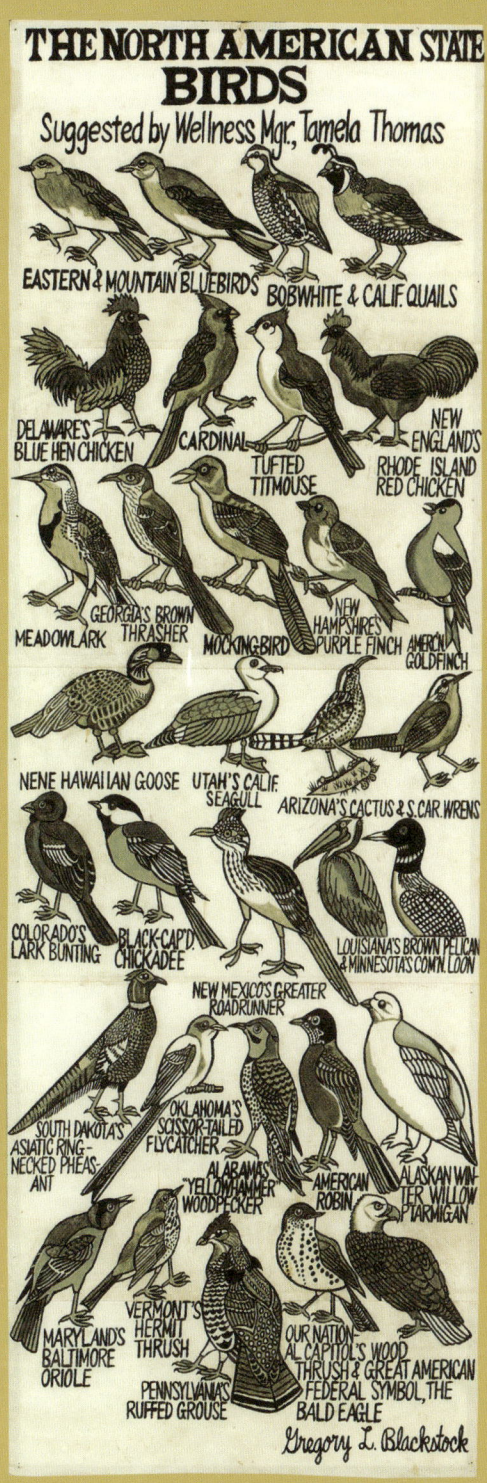

THE NORTH AMERICAN STATE BIRDS

2001 | 53 x 18 inches
Private collection

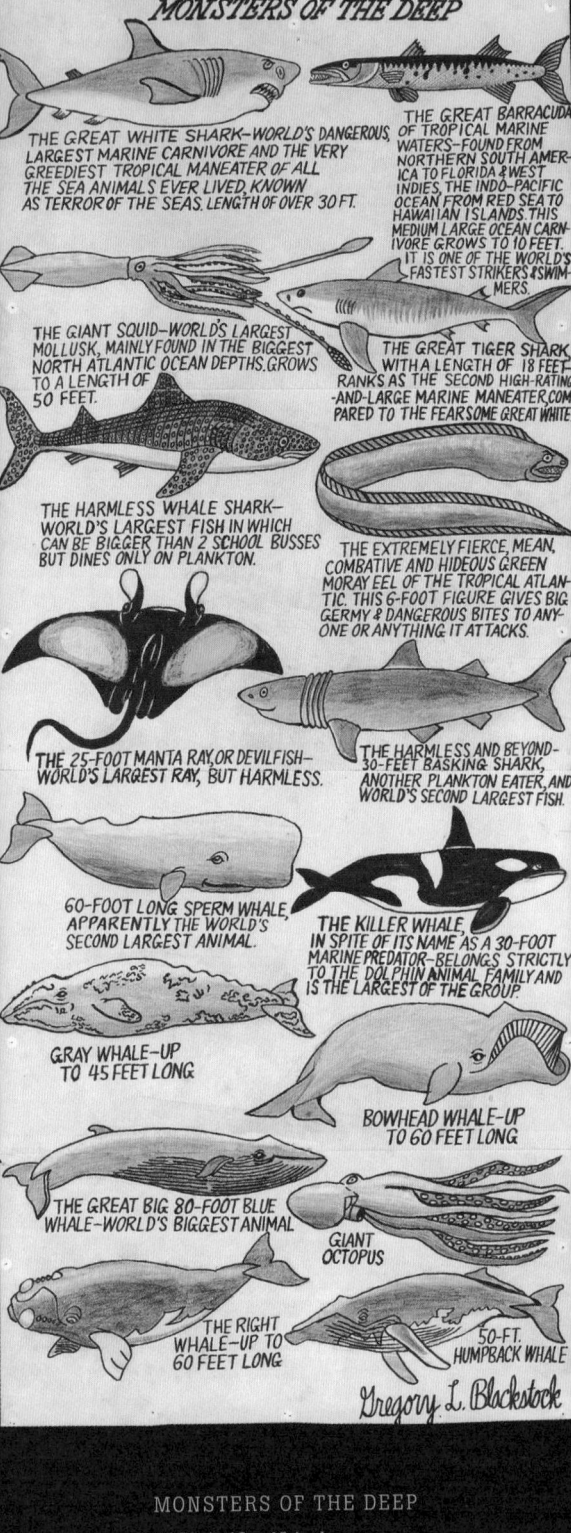

MONSTERS OF THE DEEP

1991 | 43 x 18 inches

Fish & the Like

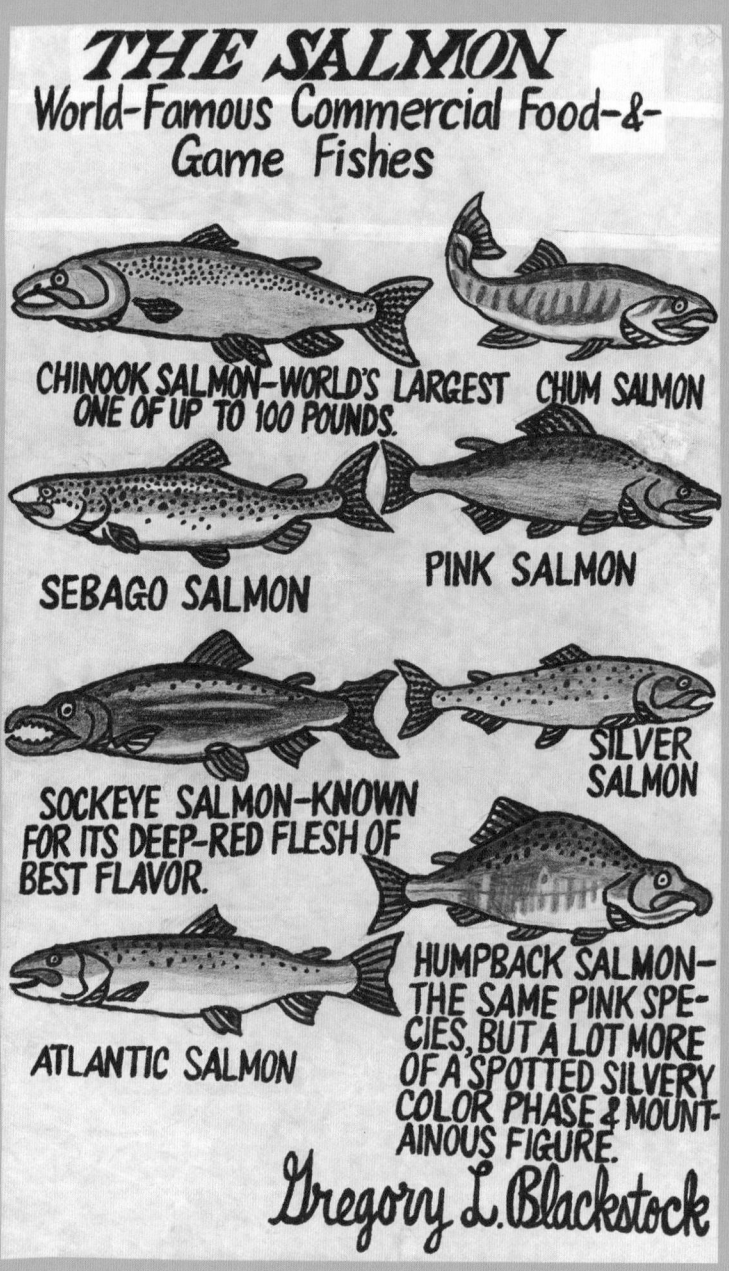

THE SALMON
2001 | 20 x 12 inches

RIGHT | THE MACKERELS
2000 | 28 x 12 inches

34

THE GLEAMING CHOWS

1990 | 21 x 12 inches
Collection of John Buck and Deborah Butterfie

The Dogs

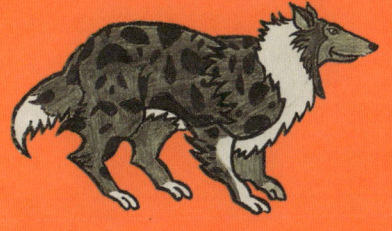

THE AIREDALE TERRIERS

WORLD'S BIGGEST & FAMOUS GAME-HUNTING DOG FRIENDS OF THIS BREED AMONG BRITISH ANCESTRY. ORIGINATED IN 1850. COLOR VARIETIES: 2.

GRIZZLE-&-TAN AIREDALE

BLACK-&-TAN AIREDALE— MOST COMMON

Gregory L. Blackstock

THE COLLIES
WORLD-FAMOUS SCOTTISH SHEEPDOGS

- LIGHT-BEARDED
- SABLE ROUGH—MOST COMMON
- ALL-WHITE ROUGH
- SMOOTH
- DARK-BEARDED
- TRICOLOR ROUGH
- BLUE MERLE ROUGH
- BORDER

Gregory L. Blackstock

THE GERMAN SHEPHERD POLICE DOGS
2005 | 37 x 24 inches

THE SCOTTISH TERRIERS
1992 | 24 x 9 inches

THE DANGEROUS ARACHNIDS

1986 | 19 x 13 inches

Insects & Arachnids

THE GREAT AMERICAN WASPS

2002 | 27 x 16 inches
Collection of John Buck and Deborah Butterfield

THE BEES

1996 | 23 x 12.5 inches

THE COLORFUL KING-SIZE SWALLOWTAIL
BUTTERFLIES OF THE WORLD

1994 | 31.5 x 19.5 inches
Collection of John Buck and Deborah Butterfield

THE GREAT WORLD JUNGLE BUTTERFLIES

SUGGESTED BY BENJAMIN SUPNET, EMPLOYEE MEAL COOK

- TAWNY RAJAH
- GREAT INDO-AUSTRALIAN MORMON
- GREAT ASIAN BLUE MORMON
- BANDED SOUTH AMERICAN MORPHO, OR CYPRIS
- SOUTH AMERICAN OWL
- GLORIOUS ASIAN BEGUM
- GREAT SOUTH AMERICAN SILVER KING SHOEMAKER
- CRAMER'S N.W. SOUTH AMERICAN BLUE MORPHO
- GREAT INDIAN LEAF
- MALAYSIAN YELLOW GORGON SWORDTAIL
- RARE BRAZILIAN DYNASTOR
- GIANT S.E. ASIAN TREE NYMPH
- BRAZILIAN GIANT BLUE MORPHO
- THE ORIENT'S JAPANESE EMPEROR
- COMMON SOUTHEAST ASIAN CLUBTAIL
- COMMON INDIAN MIME
- THE GUIANAS COCOA MORT BLEU
- S.E. ASIAN KOH-I-NOOR
- ASIAN YELLOW BODIED CLUBTAIL
- VIOLET-BANDED ASIAN LEXIAS
- GIANT ASIAN LEXIAS
- COMMON TROPICAL AMERICAN BLUE MORPHO
- SOUTHEAST ASIAN TUFTED & NORTHERN JUNGLE QUEENS

BY: Potwasher Gregory L. Blackstock

THE ANTS OF THE AMERICAS

2003 | 30 x 13 inches
Collection of Brent Lackley

RIGHT | THE MAJOR FORESTRY PESTS

1989 | 30.5 x 9 inches

THE MAJOR FORESTRY PESTS

THE SPRUCE BUDWORM MOTH, OF CANADA, COLORADO AND NORTHERN U.S.

TENT CATERPILLAR MOTHS

MOUNTAIN PINE BEETLE OF WESTERN U.S.

THE DESTRUCTIVE CARPENTER-WORM MOTH OF BROADLEAF TREES, NATIONWIDE

THE GYPSY MOTH, ACCIDENTALLY IMPORTED FROM EUROPE TO NEW ENGLAND, AND PARTLY CROSS-COUNTRY SPREAD AS FAR TO OUR WEST COAST.

Gregory L. Blackstock

THE POINSETTIAS

YELLOW POINSETTIA

RED POINSETTIA

JINGLE BELLS POINSETTIA

PEPPERMINT CANDY POINSETTIA

WHITE POINSETTIA

PINK POINSETTIA

Merry Xmas, Gregory Blackstock

The Plants

THE CARNIVOROUS PLANTS
Nature's Insect Death Traps by Gregory L. Blackstock

THE LONGLEAF SUNDEW RESEMBLES A SAGUARO CACTUS IN APPEARANCE, BUT THE BRISTLES ARE NEVERTHELESS DEADLY TO BUGS WHEN THEY BRUSH AGAINST THEM.

THE BUTTERWORT CONSISTS OF GREASY CURVE-IN LEAVES FOR TRAPS. AFTER AN INSECT SETTLES ON ANY OF THEM, IT'S A MEMBER OF THE BLADDERWORT FAMILY, & A NATIVE OF THE NORTHERN UNITED STATES.

THE ROUNDLEAF SUNDEW WHICH CONTAINS GLANDULAR-HAIRED LEAVES THAT CURL UP TO EAT INSECTS, IS ONE OF THE MOST SOPHISTICATED CARNIVOROUS PLANTS EVER GROWN.

THE LONG-HOODED VARIETY OF PITCHER PLANT KNOWN AS THE COBRA PLANT IS ALSO AN INSECT TRAPPER AFTER A BUG ENTERS ITS MOUTH IN SEARCH FOR FOOD.

THE COMMON PITCHER PLANT WITH A NUMBER OF NATURE'S HORNED PITFALLS FOR TRAPS. INSECTS CRAWL INTO THESE PITCHERS & CANNOT GET OUT. THEN THE BUGS ARE DROWNED & DIGESTED FOR FOOD.

THE BLADDERWORT - AN AQUATIC CARNIVORE WITH POUCHES TO ENGULF AND EAT UP TINY CREATURES AFTER THEY SWIM & CLIMB INSIDE THE DOORS FOR FOOD.

HOODED PITCHER PLANT - A POWERFUL INSECT TRAPPER OF THE SOUTH ATLANTIC COAST, RANGES FROM LOWER FLA. TO CAROLINAS.

WHETHER NOTICED FOR ITS TRIGGER-BRISTLED HINGES & FOUND ONLY IN THE CAROLINAS, **THE VENUS FLYTRAP** IS WORLD-FAMOUS.

THE CARNIVOROUS PLANTS

1994 | 36 x 24 inches

Our Famous Tropical Fruits
Suggested by 2nd Floor Cooks' Leader, Archie Apolonio

- MANGO
- DATES
- AVOCADO
- BANANAS
- MELON — WHICH ARE CANTALOUPES, HONEYDEWS & CASABAS
- PAPAYA
- STARFRUIT
- COCONUT
- GUAVA
- GRAPEFRUIT
- PASSIONFRUIT
- BREADFRUIT
- LEMON
- LIME
- PINEAPPLE
- CITRON
- JAMAICAN "UGLI" TANGELO
- POMEGRANATE & LITCHIBERRIES
- COCOA POD
- KIWIFRUIT
- ORANGE

Gregory L. Blackstock

The Berries

DELICIOUS & BEEFSTEAK TOMATOES — STRAWBERRY — YELLOW PEAR & BLACK PLUM TOMATOES

WHITE & CONCORD GRAPES — WATERMELON — GOOSEBERRIES — LINGONBERRIES

SNOW WHITE & GOLD MEDAL TOMATOES — BLUEBERRIES — GARDEN PEACH & RED HOTHOUSE TOMATOES

CRANBERRY — CLOUDBERRY — KIWI — NAGOONBERRY — CURRANTS

ORANGE OXHEART & RED ROMA TOMATOES — FAIRY BELL(E) & PEPPER SPICE BERRIES — ORANGE ROMA & BLACK TOMATOES

LOGANBERRY — BOYSENBERRY — BLACKBERRY — PERSIMMON — RASPBERRY — MULBERRY — DEWBERRY

THIMBLEBERRY — BRANDYWINE TOMATO — TRICOLOR HUCKLEBERRY VARIETY — TOMATILLO — SALMONBERRY

ELDERBERRY — HACKBERRY

Greg Blackstock

52

THE NUTS

2004 | 17 x 10 inches
Collection of Karen Light-Piña and Marcus Piña

LEFT | THE BERRIES

2002 | 32.5 x 12 inches
Collection of Stephen and Rose Brown

THE FAMOUS COMPOSITE FAMILY
GARDEN FLOWERS

2000 | 29 x 17.5 inches

RIGHT | THE GREAT CABBAGE FAMILY

THE GREAT CABBAGE FAMILY
World's Biggest Vegetable Variety

TURNIP

BROCCOFLOWER - A RARE GREEN CROSSBREED OF THE FAMILY.

CABBAGE, WHICH MEANS THE VARIETIES OF GREEN, SAVOY, RED & WHITE.

KOHLRABI

RUTABAGA

CAULIFLOWER

BROCCOLI

COLLARD GREEN PLANT

KALE

BRUSSELS SPROUT PLANT

Gregory L. Blackstock

THE HATCHETS
Short-Handled Choppers

BROAD HATCHET

SHINGLING HATCHET

CLAW HATCHET

LATHING HATCHET

CONSTRUCTION HATCHET

ROOFER'S HATCHET

Gregory L. Blackstock

The Tools

THE MISCELLANEOUS TOOLS

2001 | 46 x 18 inches

THE SAWS

- DOCKING SAW
- RIPSAW
- NOTCHED CIRCULAR SAW
- NAILSAW
- HANDSAW, COMMON
- HEAVY-DUTY PRUNING SAW
- DRYWALL SAW
- CROSSCUT CIRCULAR SAW
- COMPASS SAW
- KEYHOLE SAW
- SINGLE-MAN TIMBER SAW
- SINGLE-MAN CROSSCUT SAW
- CIRCULAR RIPSAW
- STRAIGHT SINGLE-EDGE PRUN.SAW
- STRAIGHT DOUBLE-EDGE PRUNING SAW
- PULLSAW
- PUSHSAW
- BRICKSAW
- MASONRY CIRCULAR SAW
- PLUMBER'S SAW
- HOLE SAW

2-MAN CROSSCUT-&-TIMBER SAWS—THE MISERY WHIPS

- WALLBOARD SAW
- HIGH-BRANCH PRUNING SAW
- JABSAW
- SINGLE-EDGE CURVED PRUNING SAW
- DOUBLE-EDGE CURVED PRUNING SAW
- WEED SAW
- HACKSAW
- V-SHAPED-&-STRAIGHT CARBIDE TIP CIRCULAR SAWS
- BUTCHER'S SAW
- FOLDING CURVED PRUNING SAW
- FOLDING STRAIGHT PRUNING SAW
- ALL-PURPOSE OUTDOOR SAW
- DOUBLE-EDGE HANDSAW
- ICE CARVER'S SAW
- IRON METAL CIRCULAR SAW
- VENEER SAW
- MITER SAW
- BACKSAW
- WOOD COMBINATION CIRCULAR SAW
- DOVETAIL SAW
- COPING SAW
- PIPESAW
- BUCKSAW
- BOWSAW
- FILETOOTH-CURVED PRUNING SAW
- INSULATION-&-FLOOR BOARD SAWS

THE HAMMERS
1988 | 16 x 8 inches

THE FILES

1997 | 22 x 9 inches
Private collection

THE DRILLS
1998 | 30 x 12 inches

THE KNIVES

- POCKET KNIFE
- PUTTY KNIFE
- HOUSEHOLD UTILITY KNIFE
- FRENCH KNIFE
- LARGE-HANDLED DENTAL PLASTER KNIFE
- SCALPEL
- LINOLEUM KNIFE
- PARING KNIFE
- SCORING KNIFE
- SKINNING KNIFE
- DINING TABLE KNIFE
- CHEESE KNIFE
- TOMATO KNIFE
- FELT KNIFE
- FISH KNIFE
- FILET KNIFE
- PEELING KNIFE
- BUTTER KNIFE
- HAM KNIFE
- PAPER HANGER'S KNIFE
- PALETTE KNIFE
- DINNER KNIFE
- HUNTER'S KNIFE
- HACKING KNIFE
- WALL-SCRAPING KNIFE
- BUTCHER'S KNIFE
- OILCLOTH KNIFE
- WOODCARVER'S KNIFE
- BONING KNIFE
- TAPE KNIFE
- OLD-FASHIONED FOOD CARVER'S KNIFE
- FARRIER'S KNIFE
- GRAPEFRUIT KNIFE
- BARBECUE KNIFE
- GOLDBEATER'S KNIFE
- CHOPPING KNIFE
- CHICKEN KNIFE
- ROAST BEEF KNIFE
- STEAK KNIFE
- CLEAVER
- CANE KNIFE
- MEZZALUNA KNIFE
- SALMON KNIFE
- BREAD KNIFE
- SLICING KNIFE
- CHEF'S KNIFE
- DRAW KNIFE
- MACHETE
- MODERN FOODCARVER'S KNIFE
- OYSTER KNIFE
- CORN KNIFE
- FRUIT-AND-VEGETABLE KNIFE

Blackstock

THE SHEARS

KITCHEN SHEARS

FLOWER SHEARS

BARBERSHOP SHEARS

PRUNING SHEARS

TAILORING SHEARS

GRASS SHEARS

TIN SHEARS

HEDGE SHEARS

Gregory L. Blackstock

THE SHEARS
1992 | 24 x 11 inches

LEFT | THE KNIVES
1989 | 36 x 18 inches

THE SPATULAS
1996 | 21 x 10.5 inches

RIGHT | THE TROWELS
2002 | 30 x 12 inches

THE TROWELS
Scooping, smoothing & finishing tools

GARDEN TROWEL

BRICK TROWEL

CAULKING TROWEL

TUCKPOINTER TROWEL

GROOVING TROWEL

EDGING TROWEL

POINTING TROWEL

TILE TROWEL

COATING TROWEL

MARGIN TROWEL

INSIDE-&-OUTSIDE CORNER TROWELS

CEMENT TROWEL

PLASTER TROWEL

SWIMMING POOL TROWEL

CURBING TROWEL

GUTTER TROWEL

SLANTED NOTCH TROWEL

CIRCULAR TROWEL

RADIUS TROWEL

Gregory L. Blackstock

THE HOES

GARDEN HOE

PLANTER'S HOE

WINGED HOE

MORTAR HOE

CRESCENT HOE

GRUB HOE

DRAW HOE

FORESTRY HOE

ONION HOE

SPADING HOE

LADIES' HOE

NURSERY HOE

WARREN HOE

WEEDING HOE

CULTIVATING HOE

SCUFFLE HOE

Gregory L. Blackstock

THE HOUSEKEEPING TOOLS

2002 | 16 x 11 inches

LEFT | THE HOES

1993 | 21 x 11 inches

THE ALARMS
Emergency-&-Time Devices

SECURITY STAFF-& BUSINESS DOOR ALARM.
Not a public access. Alarm will sound.
EMERGENCY EXIT ONLY PUSH TO OPEN & SOUND ALARM

HOME BURGLAR ALARM.
ADT

FIRE ALARM.
FIRE ALARM
PULL DOWN
SIMPLEX

AUTO ALARM.

GROUND LEVEL SWIMMING POOL ALARM.

U.S. NAVY SUBMARINE ALARM.

EMERGENCY ALARM.

CLOCK ALARM.

BUSINESS BURG. AL'RM.
PROTEC BURGLAR ALARMS (NORTHWEST) ROCHDALE 654397

ABOVE-GROUND SWIMMING POOL & SMOKE ALARMS.
POOL EYE

FOGHORN ALARM.

Gregory L. Blackstock

The Noisemakers

THE STRINGED MUSICAL INSTRUMENTS
SUGGESTED BY BARBER BILL STULL AND EXECUTIVE CHEF WILL McNAMARA

SITAR · SPINET PIANO · ELECTRIC VIOLIN · HARPSICHORD · KEMENCE (TURK'S FIDDLE)

COMMON MANDOLIN · ZITHER · RUAN · LYRE · BALALAIKA · ELECTRIC MANDOLIN · STRUM-STICK

SAMISEN · LUTE · GRAND PIANO · GUITAR · BANJO · PSALTERY

NORMAL & BASS VIOLINS · BRASS HARP · CELLO · VIOLA · FOLK HARP

LAUD · DULCIMER (STANDARD) · ELECTRIC GUITAR · UPRIGHT PIANO · COMMON AND BACKPACKER'S UKULELES

Gregory L. Blackstock

THE PIANOS

2001 | 28 x 12 inches

LEFT | THE STRINGED MUSICAL INSTRUMENTS

2000 | 34 x 15 inches

THE NOISEMAKERS

2005 | 44 x 18.5 inches
Collection of Angela Owens

THE DRUMS

- CYLINDRICAL DRUM
- KETTLE DRUM
- LONG DRUM
- BARREL DRUM
- CONICAL & GOBLET DRUMS
- FRAMED & STANDARD TAMBOURINE DRUMS
- HAND DRUM
- SINGLE & DOUBLEHEADED DRUMS
- GONG DRUM
- BASS DRUM
- COCKTAIL & CONGA DRUMS
- DJEMBI & WAISTED DRUMS
- FOOTED DRUM
- STEEL DRUM
- SNARE DRUM
- TIMBALE DRUM
- DEEP & SHALLOW
- BONGO DRUMS
- HOURGLASS DRUM
- SIDE DRUM
- CLAPPER & TENOR DRUMS
- N. AMERICAN & OLD EUROPEAN MILITARY SERVICE DRUMS
- ORIENTAL BRONZE DRUM
- HEXAGONAL DRUM
- FRAME DRUM
- TIMPANI DRUM
- FRICTION & NO. AM. INDIAN DRMS.

Gregory L. Blackstock

THE BELLS

2003 | 43 x 26 inches

LEFT | THE DRUMS

2003 | 28 x 12 inches

THE PATROL VANS

1994 | 42 x 12 inches

The Vehicles

THE FAMILY MOVING
TRUCKS

1992 | 18 x 14 inches

THE IRAQI WAR TANKS

1991 | 14 x 8 inches

THE EMERGENCY TRUCKS

1992 | 29.5 x 9 inches

OUR OLD-TIME FREIGHT TRAIN EQPM'T.

DIESEL TRAINMASTER LOCOMOTIVE. IRON ORE CAR. DUMPCAR. DIESEL SWITCHER LOCOMOTIVE.

COMMON FLATCAR. DEPRESSED-CENTER FLATCAR. AUTOMOBILE-&-PIGGYBACK FLATCARS.

SINGLE-&-DOUBLE-DECKER CATTLE CARS. OPEN-&-COVERED CEMENT CARS.

OPEN-&-AUTOMATIC DUMP DOOR HOPPER CARS. AUTOMOBILE-&-LUMBERING BOXCARS.

METAL-BRACED WOODEN & STEEL BOXCARS. TWIN-&-TRIPLE-BAY COVERED HOPPERS.

SINGLE-DOMED-&-CHEMICAL TANKCARS. ALL-WOOD-&-METAL REFRIGERATOR CARS.

OPEN-&-COVERED GONDOLA CARS. WOOD-&-METAL STYLE COAL HOPPER CARS.

RARE 6-DOMED & MILK TANK CARS. LOGGING SKELETON-&-FLAT CARS.

COPPER ORE CAR. METAL-BRACED WOODEN-&-STEEL WOODCHIP CARS. 2-DOMED TANKCAR.

ANTIQUE WOODEN-3-DOMED-&-ANCIENT OIL TANKCARS. COKE-&-COAL CAR.

DOUBLE-ENDED BULKHEAD & LUMBER-MAN'S OLD SKELETON FLATCARS. FURNITURE CAR. CABOOSE.

Gregory L. Blackstock

THE RACE CARS

1991 | 20.5 x 7.5 inches

LEFT | OUR OLD-TIME FREIGHT TRAIN EQUIPMENT

OUR FAMOUS ANTIQUE CARS
1995 | 18 x 13 inches

RIGHT | THE LAW & ORDER
AUTHORITY VANS
2005 | 49 x 25 inches

THE LAW-&-ORDER AUTHORITY VANS
OUR LOCAL GOV'T OFFICERS' COMPLETE SET OF THEIR PATROL VEHICLES

COUNTY POLICE FORCE-&-SHERIFFS' SUPER CRIMESTOPPER VANS

CITY POLICE PADDYWAGON-&-LIEUTENANT VANS

NATIONAL PARK RANGER VAN

F.B.I.'S PROTECTIVE SERVICE POLICE VAN

UNIVERSITY DISTRICT POLICE VAN

STATE PATROL POLICE VAN

PUBLIC BUSINESS SAFETY SECURITY GUARDS' VAN

PORT POLICE FORCE VAN

CITY POLICE PARKING ENFORCEMENT-&-COMMUNICATION VANS

CITY POLICE UTILITY VAN

F.B.I.'S JUSTICE DE-PARTMENT VAN

METROPOLITAN-&-COUNTY BUS COMPANIES' PREMIER POLICE VANS

Gregory L. Blackstock

85

THE CONVAIR-LINERS

UNITED AIR LINES CONVAIR 340— WITH TWO PRATT-AND-WHITNEY R-2800 CB-16 RADIAL PISTON ENGINES AND 3-BLADED AIRSCREWS

THE NAPIER ELAND TURBOLINER CONVAIR 540—LEASED TO ALLEGHENY AIRLINES OF THE EAST COAST IN 1959 AS A MODIFICATION OF THE 340, AND FOR THE FIRST TIME CONVERTED TO TURBINE POWER.

THE FRONTIER AIRLINES ALLISON JET-POWER CONVAIR 580 OF 1964.

THE ROLLS ROYCE DART SUPER TURBO CONVAIR 640 OF THE MID 1960s TO THE '70s—THE LATEST MEMBER OF THE GENERAL DYNAMICS CONVERSION.

Gregory L. Blackstock

THE CONVAIR-LINERS

1987 | 29 x 13 inches

Aviation Collection

THE WORLD WAR 2 BRITISH BOMBERS

THE ARMSTRONG WHITWORTH WHITLEY — 1939

THE VICKERS ARMSTRONG WINDSOR

THE SHORT STIRLING OF 1940.

THE HANDLEY PAGE HALIFAX II - EARLY 40s (WITH ROLLS ROYCE MERLIN ENGINES)

THE HANDLEY PAGE HALIFAX MARK 6 WITH BRISTOL HERCULES ENGINES

THE AVRO MANCHESTER — 1940

AVRO LINCOLN OF 1944.

THE AVRO "DAM BUSTER" LANCASTER — 1942

FAIREY BATTLE — 1937.

THE VICKERS WELLESLEY — 1937

THE VICKERS ARMSTRONG WELLINGTON — 1938

BRISTOL BRIGAND — 1942

THE BRISTOL BUCKINGHAM — 1942

THE BRISTOL BLENHEIM — 39

THE HANDLEY PAGE HAMPDEN — 1940

THE HANDLEY PAGE HARROW — 1937

Gregory L. Blackstock

OUR FAMOUS WORLD WAR 2 ALLY FIGHTERS COMPLETE
Suggested by Barber Bill Stull & Food-&-Beverage Vice-President, Mr. Robert Bonina

- FRENCH ARSENAL VG-30 SERIES
- U.S. ARMY BELL P-59 AIRACOMET JET
- FRENCH DEWOITINE D-520
- U.S. ARMY BELL P-39 AIRACOBRA
- FRENCH BLOCH MB-152C-1
- U.S. ARMY CURTISS P-40 "FLYING TIGER" WARHAWK
- BRITISH BOULTON PAUL DEFIANT
- U.S. ARMY BELL P-63 KINGCOBRA
- FAMOUS BRITISH DE HAVILLAND MOSQUITO F.B. MK. VI
- U.S. NAVY CHANCE VOUGHT F4U-1 CORSAIR
- BRITISH BRISTOL BEAUFIGHTER
- U.S. NAVY GRUMMAN F4F WILDCAT
- BRITISH DE HAVILLAND VAMPIRE JET
- U.S. NAVY GRUMMAN F6F HELLCAT
- BRITISH GLOSTER METEOR JET
- U.S. NAVY BREWSTER F2A BUFFALO
- BRITISH DE HAVILLAND HORNET F3
- U.S. NAVY GRUMMAN F7F TIGERCAT
- BRITISH FAIREY FULMAR
- U.S. NAVY GRUMMAN F8F BEARCAT
- BRITISH FAIREY FIREFLY MK.1
- U.S. AIR FORCE LOCKHEED P-38 LIGHTNING
- BRITISH HAWKER HURRICANE
- MARTIN AM MAULER-U.S. NAVY ATTACK PLANE
- BRITISH HAWKER TORNADO
- U.S. AIR FORCE LOCKHEED P-80 SHOOTINGSTAR JET
- BRITISH HAWKER TYPHOON
- RUSSIAN ILYUSHIN 2 "TANK KILLER" STORMOVIK-THE ANGEL OF DEATH
- BRITISH HAWKER TEMPEST MARK V
- ILYUSHIN 10-RUSSIAN GROUND ATTACK AIRPLANE, SIMILAR TO STORMOVIK, THE IL-2
- NORTH AMERICAN P-51D-5-NA MUSTANG- ABOUT THE BEST FIGHTER KNOWN
- FRENCH MORANE-SAULNIER M.S. 406
- NORTH AMERICAN P-51H MUSTANG
- RUSSIAN LAVOCHKIN LAGG-3
- BRITISH MILES M.20
- RUSSIAN LAVOCHKIN LA-5N
- BRITISH SUPERMARINE SPITFIRE 9
- RUSSIAN MIKOYAN-GUREVICH MIG-3 FOR EVERY SEASON KNOWN
- BRITISH SUPERMARINE SPITFIRE 14
- RUSSIAN YAKOVLEV YAK-4 GROUND ATTACK FIGHTER
- BRITISH WESTLAND WHIRLWIND
- RUSSIAN YAKOVLEV YAK-9
- U.S. NAVY NORTHROP P-61 BLACK WIDOW
- RUSSIAN POLIKARPOV I-16
- U.S. AIR FORCE REPUBLIC P-47D-25-RE THUNDERBOLT

Gregory L. Blackstock

THE GOLDEN AGE OF HISTORIC
UNITED AIR LINERS

1995 | 31 x 23 inches
Collection of Eric Carnell

RIGHT | THE HISTORIC AMERICAS
TURBOLINERS

2004 | 41 x 19 inches

THE HISTORIC AMERICAS TURBOLINERS
PROPELLOR JET AIRCRAFT 1950-1965

RUSSIAN ANTONOV AN-24 OF CUBANA DE AVIACIÓN - 1964.

THE OLD-TIME BRITISH BRISTOL 175 BRITANNIA, ONE OF THE HANDSOMEST TURBO(E)S EVER BEEN BUILT AMONG AIRCRAFT, IN THE 1950s. THIS BOUGHT BY CPA

THE CANADAIR CL-44D-4 TURBO-FREIGHTER VERSION OF BRITANNIA -'62.

FOKKER FAIRCHILD HILLER F-27 FRIENDSHIP, OF 1959

THE NAPIER ELAND TURBOLINER CONVAIR 540 -'59, AS AN EXPERIMENT - FROM 340

LOCKHEED L-188C ELECTRA - 1957

ALSO THE ILYUSHIN "RUSSIAN ELECTRA" IL-18 BOUGHT BY CUBANA IN THE 1960s.

THE ALLISON TURBOLINER CONVAIR 580 OF THE EARLY 60s.

THE ROLLS ROYCE DART TURBOLINER CONVAIR 600 OF 1965, AS A MODIFICATION OF THE 240.

THIS VICKERS VISCOUNT 700 - WORLD'S OLDEST TURBOLINER BUT, BOUGHT BY UAL -1955.

THE 1959-RELEASED BRITISH VICKERS VANGUARD - BOUGHT BY AIR CANADA IN THE MID-60s.

THE ROLLS ROYCE DART SUPER TURBOLINER CONVAIR 640 CONVERSION OF 440 METROPOLITAN RADIAL AIRCRAFT -1965.

THIS JAPANESE N.A.M.C. YS-11 OF EASTERN N. AM.'S PIEDMONT AIRLINES -'60s.

THIS BRITISH VICKERS VISCOUNT 800 SERIES OF SO. AM'S PLUNA A.L., MADE '56.

THIS 1958-BUILT BRITISH HANDLEY PAGE HERALD SOLD TO JERSEY AIRLINES OF THE ATLANTIC SEABOARD.

THE BRITISH HAWKER SIDDELEY AEROSPACE 748 OF WESTERN NORTH AMERICA'S CASC. ARWYS '60s

Gregory L. Blackstock

91

THE EARLY BOEING
JET PLANES

1993 | 44 x 12 inches

RIGHT | THE BIG JETS

1989 | 43 x 17 inches

THE BIG JETS

AEROFLOT AIRWAYS RUSSIAN TUPOLEV 144
SUPERSONIC TRANSPORT

BRITISH AIRWAYS FRENCH CONCORDE
SUPERSONIC TRANSPORT

PAN AMERICAN
WORLD AIRWAYS U.S.
BOEING 747 JUMBOJET

DELTA AIRLINES U.S. LOCKHEED TRISTAR
SUPERJET

AMERICAN AIRLINES McDONNELL
DOUGLAS SUPER DC-10 JET

UNITED AIR LINES
McDONNELL DOUGLAS DC-8
SUPER 60 FANJET

TRANS WORLD AIRLINES U.S.
BOEING 767 JET

OLYMPIC AIRWAYS EUROPEAN
AIRBUS INDUSTRIE JET 300

Gregory L. Blackstock

THE WORLD WAR 2 U.S. BOMBERS
2003 | 58 x 22.5 inches

THE WORLD WAR 2 MESSERSCHMITT
GERMAN FIGHTER PLANES COMPLETE

2001 | 44 x 19 inches

THE HISTORIC D OUTBOARD RACEBOAT EQPMT.
OF THE 1950s-1970s NORTHERNMOST U.S. REGION

105-P / **Q-131**
EARLY MERCURY KG-9 D STOCK — AND — OPEN MARK 50 RACING OUTBOARD HYDROS

104-J / **S-308**
EARLY MERCURY KG-9 D STOCK — AND — OPEN MARK 50 RACING OUTBOARD RUNABOUTS

B-107 / **555-D**
OLD MERCURY MARK 40 D STOCK & SINGLE-STACK OPEN MARK 50 RACING OUTBOARD HYDROS

N-350 / **8-R**
OLD MERCURY MK. 40 D STOCK & SINGLE-STACK CLOSED MARK 50 RACING OUTBOARD RUNABOUTS

M-1 / **A-500**
MERCURY MARK 55 D STOCK HYDRO / SINGLE-STACK KOENIG D OUTBOARD HYDRO

H-115 / **V-705**
MERCURY MARK 55 D STOCK RUN. / SIAMESE-STACK KOENIG D RACING RUN.

W-12 / **307-G**
LOOPER D RACING OUTBOARD HYDRO / SIAMESE-STACK CLOSED MERCURY MARK 50 D RACING OUTBOARD HYD.

X-711 / **U-900**
LOOPER D RACING OUT. RUNABOUT / SIAMESE-STACK OPEN MERCURY MARK 58A D RACING OUTBOARD RUN.

INDICATIONS OF THESE OUTBOARD BOAT RACE REGIONS

A - NORTHERN NEW ENGLAND.
B - MASSACHUSETTS.
D - R.I. & CONN. G - S.D. & MINN.
H - INDIANA. J - NEW JERSEY.
M - MICHIGAN.
N - NEW YORK.
P - PENNSYLVANIA.
Q - DELAWARE.
R - IDAHO & PAC. N.W. STATES.
S - OHIO, U - N.D. & ROCKY MTNS.
V - ILLINOIS. W - WISCONSIN.
X - NEBRASKA & IOWA.

Gregory L. Blackstock

Boating & Seamanship

THE HISTORIC F OUTBOARD RACEBOAT EQUIPMENT
2004 | 44 x 24 inches

OUR EARLY UNLIMITED INBOARD
HYDROPLANES

2005 | 44 x 24 inches

The Simple Knotting (COMMON)

OVERHAND KNOT | OVERHAND LOOP

THE SQUARE KNOT, OR REEF KNOT IS ONE OF THE COMMONEST, EASIEST, STRONGEST & SAFEST AMONG KNOTS ON EARTH EVER HAD IN SCOUTING & SEAMANSHIP. AS A REAL ANCIENT & "DANGERPROOF" ATTACHMENT, IT IS ALSO KNOWN AS THE TRUE, HARD, FLAT, COMMON, REGULAR, STEADY, FIRM OR ORDINARY KNOT. CAN ALSO CONVERT INTO REVERSED HALF HITCHES.

THE GRANNY KNOT, OR FALSE, LOUT'S, LUBBER'S, BAD-SHOT, POORHAND, KNOW-NOTHING, OAF, IDIOT, IGNORAMUS, GREENHORN, DUNCE, CALF & BOOBY KNOT—IS EVER SO OFTEN TIED ACCIDENTALLY BY MISTAKE INSTEAD OF A SQUARE KNOT, FORMING A REAL SLIPPERY, JAMMING & RISKY ATTACHMENT WHICH ABSOLUTELY NEVER SHOULD BE USED ITSELF FOR ANY PURPOSE IN THE 1ST PLACE... UNLESS AFTER IT IS CONVERTED INTO 2 HALF HITCHES **OR SLIDE KNOT AS A MATTER OF SAFETY.**

BLOOD KNOT | FIGURE-8 KNOT

BRAIDED-&-DOUBLE FIGURE-8 KNOTS

TRIPLE-&-QUADRUPLE FIGURE-8 KNOTS

MULTIPLE-&-ROUND-TURN FIGURE-8 KNOTS

FIGURE-8 LOOP
ANGLER'S LOOP

SINGLE-&-DOUBLE MAN-HARNESS LOOPS. | INDIAN BRIDLE LOOP | CASK LOOP | SAILOR'S BREASTPLATE LOOP | LINEMAN'S LOOP

SINGLED-&-DOUBLED FISHERMAN'S KNOTS

FIGURE-8 FISHERMAN'S KNOT | SURGEON'S KNOT

STEVEDORE KNOT

SLIDE KNOT | LUMBERMAN'S KNOT, USED MAINLY AS TIMBER HITCH PURPOSES. | JAPANESE CROWN LOOP. | TWIN-&-TRIPLE LEAF TRIANGLE KNOTS. | CRABBER'S EYE KNOT.

SLIPKNOT

Gray Blackstock

THE EASY ORNAMENTAL SHEEPSHANKS
2005 | 26 x 19 inches

LEFT | THE SIMPLE KNOTTING

2005 | 42 x 18.5 inches

Scouting & Seamanship
Sheepshanks
Famous Knotted Bight Figures Used to Shorten Ropes

COMMON SHEEPSHANK

CLOVE HITCH SHEEPSHANK

PRETZEL MARLINE HITCH SHEEPSHANK - ONE OF THE STRONGEST

DOUBLE OVERHAND SHEEPSHANK

ROLLING HITCH SHEEPSHANK

MARLINE HITCH SHEEPSHANK - THE SAFEST OF ALL THESE KNOTS.

Gregory L. Blackstock

THE BUOYS

1998 | 18 x 13 inches

LEFT | SCOUTING & SEAMANSHIP
SHEEPSHANKS

1994 | 25 x 12 inches

THE ORIENTAL TEMPLES

1993 | 37 x 12 inches
Collection of Lynda Gilman

Architectural Collection

THE ROOFS

- LEAN-TO ROOF
- BUTTERFLY ROOF
- PAVILION ROOF
- FLAT ROOF
- GAMBREL ROOF
- HIP ROOF
- SLOPED TURRET ROOF
- PITCHED ROOF
- DOME ROOF
- HIP & VALLEY CROSS ROOF
- ROTUNDA ROOF
- MONITOR ROOF
- IMPERIAL ROOF
- HELM ROOF
- GABLE ROOF
- BELL ROOF
- RESIDENTIAL CAPE COD HOUSE DORMER ROOF
- WATERTOWER ROOF
- TWIN-DORMER & STEEPLE ROOFS
- SAWTOOTH ROOF
- SINGLE-DORMER PYRAMID ROOF
- OGEE ROOF
- TRIPLE-DORMER ROOF
- CONICAL BROACH ROOF
- MANSARD ROOF

Gregory L. Blackstock

THE TENTS
1993 | 16.5 x 8 inches

LEFT | THE ROOFS
1999 | 26.5 x 12 inches

THE BARNS

2003 | 60 x 28 inches
Collection of Microsoft Corporation

THE U.S. PRESIDENT MEMORIALS
1993 | 23 x 12 inches

RIGHT | THE HISTORIC AMERICAN HOMES
1990 | 23.5 x 12 inches

THE HISTORIC AMERICAN HOMES

NEW HAMPSHIRE GEORGIAN HOUSE

HOPI INDIANS' PUEBLO ADOBE HOME, ARIZONA

IROQUOIS INDIANS' HOME OF THE EASTERN WOODLANDS

MASSACHUSETTS SALT BOX HOUSE

SOUTHERN U.S. COLONIAL HOME

OLD-FASHIONED TEXAS FRONTIER HOME

BOSTON'S OLD PAUL REVERE HOME OF THE 1600s.

MODIFIED CAPE COD HOUSE, MASS.

Gregory L. Blackstock

OUR STATE LIGHTHOUSES

2000 | 28 x 13 inches

THE WORLD LANDMARK TOWERS

1994 | 31.5 x 12.5 inches

THE VACATIONERS' IRISH CASTLES

1994 | 39 x 26 inches

RIGHT | OUR STATE'S KING-SIZE JAILS

2004 | 37 x 18 inches
Collection of Elin Martin and Michael S. Morris

OUR STATE'S KING-SIZE JAILS

MONROE SNOHOMISH COUNTY'S WASH. ST. REFORMATORY

NEW TACOMA PIERCE CO. JAIL, EVERETT SNOH. COUNTY JAIL

TACOMA PIERCE COUNTY SHERIFFS' DETENTION-&-CORRECTION CENTER **KENNEWICK'S BENTON COUNTY JAIL**

WALLA WALLA'S GREAT WASHINGTON STATE PENITENTIARY

OLD McNEIL ISLAND PIERCE CO. JAIL BUILDING OF STEILACOOM **VANCOUVER, WN.'S CLARK CO. LAW ENF. CTR.**

WENATCHEE'S CHELAN COUNTY REGION JAIL. AUTHORITIES' **SEATTLE KING COUNTY LAW-&-ORDER CORRECTIONAL FACILITY JAIL**

LARGEST LOCAL GOV'T DISCIPLINE-&-JUSTICE CENTERS BY: J.L. Blackstock

115

THE HISTORIC INTERCONTINENTAL HOMES
2001 | 50 x 23 inches

RTHERN GERM-
RMHOUSE
2-STORY JAPANESE WOOD-
& PAPER HOUSE
SYRIAN VILLAGE CON-
CRETE BEEHIVE
HOUSE
NEWMAN IRISH
HOUSE
MEWS
ON SQUARE
THATCHED
BAVARIAN HOME
URAL MOUNTAIN
RANGE COTTAGE, RUSSIA
BERMIN
NEW HEBRIDES PILE
HOUSE
TEAK HOUSE
OLD THATCHED IRISH COTTAGE
RUSS
RIAN
SEGOVIA'S SPANISH
ALCAZAR CASTLE
NORTHERN CHINESE
CONCRETE BRICK HOUSE,
ENGLISH
CASTLE
LONGFI
SWISS MOUNTAIN CHALET
CENTRAL EUROPEAN
CABIN
ELLIOTT SOU
RAVAN
SH HOME
17TH CENTURY FRENCH
(CASTLE) CHATEAU
17TH CENTURY TIBETAN
FORTRESS PALACE
CE

THE GREAT GREEK TEMPLES
1992 | 17 x 12 inches

RIGHT | THE HISTORIC ROMAN TEMPLES
1992 | 24 x 12 inches

THE HISTORIC ROMAN TEMPLES

THE VILLA ROTONDA, DESIGNED BY ANDREA PALLADIO IN THE MID-1500s, WHICH IS BUILT ON A HILL NEAR VICENZA. THE FLAT DOME INDICATES THE CENTER HALL OF THIS OLD ITALIAN STRUCTURE.

ROME'S FAMOUS PANTHEON, BUILT BY AGRIPPA 27 YEARS BEFORE CHRIST, AND REBUILT BY HADRIAN A.D. IN THE 2ND CENTURY, & USED SINCE 609 A.D. AS A CHRISTIAN CHURCH

Greg Blackstock

THE HATS

- DERBY HAT
- TRAIN CONDUCTOR'S HAT
- SOMBRERO
- FIREMAN'S HAT
- PARK RANGER'S HAT
- "TAME" INDIAN HAT
- CONTRACTOR'S HAT
- OUR CLUB DOORMAN'S HAT
- BOWLER HAT
- BASEBALL PLAYER'S HAT
- CHEF'S HAT
- LUMBERJACK'S HAT
- COAL MINER'S HAT
- POLICE OFFICER'S HAT
- TEXAS STETSON HAT
- PARADE BANDLEADER'S HAT
- SHIP CAPTAIN'S HAT
- FOOTBALL PLAYER'S HAT

BY: Potwasher Gregory L. Blackstock

THE HATS

1992 | 17.5 x 9 inches
Collection of Thomas and Heather Harvey

The Things to Wear

G-BACK LADIES' SHOE · TENNIS SHOE · STEP-IN MEN'S SHOE · MON OXFORD MEN'S SHOE · T-STRAP LADIES' SHOE · HAMMER THROWER'S SHOE · OG LADIES' SHOE · MOCCASIN SHOE · HIGH PUMP LADIES' SHOE · STEP-IN LADIES' S[HOE] · BOOTEE MEN'S SHOE · STEEPLECHASE RACER'S SHOE · [B]ALLERINA LADIES' SHOE · CROSS-COUNTRY MAN'S SHOE · BLUCHER OXFOR[D] MEN'S SHOE · [JA]MES BOND MOVIE VILLAINS' MAKE-[SHIFT?] DEADLY SWITCHBLADE SHOE—"[F]ROM RUS[SIA WITH] LOVE" · SLINGBACK LADIES' SANDAL SHOE · LOW-PUMP LADIE[S] SHOE · [AN]GLE-BAR LADIES' SHOE · ESPADRILLE SHOE · HIGH-JUMPER'S SHOE · [VOL]LEYBALL SHOE · CASUAL LADIES' SHOE · T-STRAP SANDAL SH[OE]

THE SHOES

1996 | 30.5 x 17.5 inches
Collection of David and Gail Karges

20 OF OUR NORTH AMERICAN MEN'S
MAJOR LEAGUE BASEBALL UNIFORMS

1999 | 32 x 19 inches
Collection of Greg Kucera and Larry Yocom

THE MASKS

2002 | 32.5 x 18 inches

THE CROSSES

1994 | 22 x 18 inches

The Last But Not Least

MONSTERS OF THE PAST
Famous Giant Reptiles of Prehistory

THE 87-FOOT DIPLODOCUS—ONE OF THE WORLD'S LARGEST HERBIVOROUS DINOSAURS

THE 40-FOOT ICHTHYOSAUR—GIANT FISH-LIKE REPTILE

THE 20-30 FOOT HEAVY-ARMORED STEGOSAURUS—ONE OF THE MANY LAND HERBIVOROUS DINOSAURS.

THE 50-FOOT CARRION-EATING TYRANNOSAURUS REX—LARGEST CARNIVORE AMONG EARLY REPTILES

THE 65-FOOT BRONTOSAURUS—A LARGE HERBIVORE KNOWN AS THE THUNDER DINOSAUR

THE PTERODACTYL—A LARGE TAILLESS, MEMBRANED FLYING REPTILE AT THE END OF THE MESOZOIC ERA.

THE 30-FOOT RHINOLIKE TRICERATOPS—ANOTHER HERBIVOROUS DINOSAUR

THE HUGE 50-FOOT MARINE ELASMOSAUR-LIKE PLESIOSAUR ONLY BIGGER.

Gregory L. Blackstock

THE WORLD'S DANGEROUS PIT-VIPERS

WESTERN DIAMONDBACK RATTLER.

A VERY MEAN, SHORT-TEMPERED, DANGEROUS SPECIES OF THE AMERICAN SOUTHWEST, AND ABOUT THE MOST FATALLY-VENOMOUS IN NORTH AMERICA—COMPARED TO THE LARGER EASTERN DIAMONDBACK OF THE SOUTHEAST.

THE DEADLY FER-DE-LANCE OF TROPICAL AMERICA. A DANGEROUS MENACE TO FARMERS AND PLANTATION WORKERS, AND RESPONSIBLE FOR SEVERAL THOUSAND DEATHS ANNUALLY COMBINED. THE FRENCH NAME FOR THIS GREAT SNAKE MEANS LANCE-SHAPED HEAD, AND THIS CREATURE RANGES FROM SOUTHERN MEXICO TO THE NORTHERN EDGE OF THE AMAZON BASIN IN BRAZIL.

THE BUSHMASTER—WORLD'S LARGEST PIT-VIPER, WITH A LENGTH OF UP TO 12 FEET SOMEWHAT LESS THAN THE HARMLESS BOA CONSTRICTOR—IS THE MOST FEARED SNAKE IN LATIN AMERICA. IT RANGES FROM SOUTHERN NICARAGUA TO THE NORTHERN EDGE OF THE AMAZON BASIN IN BRAZIL, AND ON THE WEST INDIES ISLAND OF TRINIDAD. ACCORDING TO MY DAD WHO WAS STATIONED IN TRINIDAD DURING WORLD WAR 2, THIS SERPENT'S VENOM IS EXTREMELY DANGEROUS, WITH ITS BITE MORE OFTEN DEADLY TO HUMANS THAN THAT OF THE FER-DE-LANCE.

EASTERN DIAMONDBACK RATTLER OF THE AMERICAN SOUTHEAST—LARGEST OF ALL NORTH AMERICAN POISONOUS SNAKES.

Gregory L. Blackstock

THE WORLD'S DANGEROUS PIT-VIPERS

1987 | 20 x 18 inches

LEFT | MONSTERS OF THE PAST

THE BALLS
1998 | 30 x 16 inches

LEFT | THE KITES
1998 | 21.5 x 8.5 inches

The Classical Clowns

SUGGESTED BY MICHAEL HARKNESS

LOU JACOBS	HARRY LANGDON	COCO
ABE GOLDSTEIN	BOZO	VETERAN HARRY ROSS
J.P. PATCHES	RED SKELTON	BOBBY KAY
FILMSTAR-CLOWN ERNEST BORGNINE	EMMETT KELLY	"PINTO" COLVIG

Gregory L. Blackstock

THE GREAT AMERICAN PRESIDENTS
1989 | 17 x 11 inches

LEFT | THE CLASSICAL CLOWNS
1995 | 31 x 17 inches
Collection of Darold Andersen

COUNTY WICKLOW MONUMENT & CELTIC CASTLE SYMBOL TOWERS

IRISH FLY SWATTER & NATIONAL FLAG

KINSALE'S OLD HEAD LIGHTHOUSE OF THE COUNTY CORK SEACOAST

OLD DOMED GATEWAY ARCH OF DUBLIN'S TRINITY COLLEGE

IRISH WATER SPANIEL DOG FORMAL

SHAMROCK SUNGLASSES

IRISH HIGH-TOP & BOWLER HATS

SHAMROCK LIGHT BULB

IRISH DERBY & MAD HATTER HATS

LEPRECHAUN FARMER

IRISH HOT AIR BALLOON & HARP

IRISH COCKTAIL PICK

SAINT PATRICK'S DAY FLAG & MAILBOX

IRISH SOCK

CELTIC CROSS

TRUE SHAMROCK LEAFLET

WHEN MERRY SHAMROCKS & IRISH I'S ARE SMILING!

JEWEL TATTOO & 3-IN-ONE SHAMROCKS

IRISH PARTY CUP

FORMAL IRISH TERRIER DOG

SYMBOLIC RED-&-SPOTTED WHITE IRISH SETTER DOGS

IRISH NECKTIE

BLENNERVILLE WINDMILL

IRISH & SNARE DRUM

THE IRISH JOYS

2003 | 47 x 22 inches

CRAYOLA WATERCOLORS
2005 | 71/2 x 20 inches

CRAYOLA CRAYONS
2005 | 19 x 20 inches
Collection of Greg Kucera and Larry Yocom

RIGHT | THE ART SUPPLIES
2004 | 32 x 17 inches

THE ART SUPPLIES

- CRAYON
- BONE FOLDER
- BOOKBINDER'S NEEDLE
- COMMON ERASER PENCIL
- FABRIC PAINT
- SINGLE MARKING PEN
- GRIPSTER
- INDIA INK
- SHARPWRITER PENCIL
- POUNCE WHEEL
- PAINT PALETTE
- STUMP
- FIXED BALL-POINT PEN
- Artist's Oil Color PLUM
- WATERCOLOR PENCIL
- CHARCOAL PENCIL
- OIL PASTEL
- INK-&-LEAD ERASER
- TEXTILE MARKER
- OIL PAINT
- TJANTING TOOL
- COMMON ERASER
- INK PEN
- Liquid Paper
- RETRACTABLE BALL-PT. PEN
- COLOR PENCIL
- DVP ARTIST'S WATER COLOR MULBERRY
- LIQUID PAPER
- SMALL PAINTBRUSH
- PLASTIC PAL. KNIFE
- PLAIN PENCIL
- TINY PAINTBRUSH
- WATERCOLOR PAINT
- MEDIUM PAINTBRUSH
- CHINA MARKER PENCIL
- GOLDEN ACRYLICS TAN
- CRAYOLA CRAYONS 64 DIFFERENT BRILLIANT COLORS NEW! BUILT-IN SHARPENER
- MAROON
- CHALK CRAYON
- CRAYOLA WATERCOLORS
- WATERCOLOR SET
- ACRYLIC PAINT TUBE-&-JAR
- ARTWORK MARKER
- ORIGINAL 1958 CRAYON BOX 64
- HIGHLIGHT MARKER
- LARGE PAINTBRUSH
- Mead ACADÉMIE Drawing Pad
- DOUBLE MARKING PEN
- FINE-PT. MARKING PEN
- DRAWING PAD-DISTANT VIEW
- HIGHLIGHT MARKER PEN
- ERASABLE & MICRON PENS
- ORCHID MICRON
- ERASER-&-COLOR PENS

COMPLETE SET OF WORKMAN-SHIP-&-SCHOOL EQUIPMENT BY: *Gregory L. Blackstock*

The Christmas Trappings

- 5-DIMENTIONAL STAR
- CHRISTMAS LITE BULB
- PEPPERMINT CANE
- CHRISTMAS BELL
- CHRISTMAS GIFT
- CHRISTMAS STOCKING
- CHRISTMAS BALL
- CHRISTMAS CANDLE
- CHRISTMAS FLAME BULB
- HOLLY BOUGH
- CHRISTMAS CAP
- POINSETTIA
- CHRISTMAS CANDY STICK
- CHRISTMAS PINE CONE
- CHRISTMAS GRINCH
- XMAS OUTDOOR LAMP
- SANTA CLAUS FACE
- CHRISTMAS WREATH
- CHRISTMAS CRYSTAL BULB
- CHRISTMAS TREE
- CHRISTMAS LANTERN
- CHRISTMAS NOBLE FIR CONE
- CHRISTMAS ALPINE FIR CONE
- CHRISTMAS JINGLES
- XMAS SPRUCE CONE
- SWAG
- MISTLETOE BOUGH
- REINDEER
- SANTA CLAUS SLEIGH
- SNOWMAN

Gregory L. Blackstock

THE SKIERS
1992 | 18 x 12 inches

LEFT | THE CHRISTMAS TRAPPINGS
1987 | 36 x 12 inches

PAGE 140 | THE BASKETS
2002 | 27 x 12 inches
Collection of Greg Kucera and Larry Yocom

PAGE 141 | COLORFUL EGG PATTERN FAVORITES TO GO FOR
2005 | 83 x 46.5 inches

PAGE 142 | MORE COLORFUL EGG PATTERN FAVORITES TO GO FOR
2005 | 101 x 49 inches

THE BASKETS

WOVEN PLAIN & CHECKERBOARDED PAPER BASKETS

HOTEL MAID'S BASKET

SLATED MERCHANDISE & HANGING FLOWR. BKTS.

BICYCLE WIRE & FILM BASKETS

WICKER FLOWER & GROCERY BASKETS

BUCKET & FUNNEL BALL GAME BASKETS

TUBULAR ROUND- & OVOID WASTE BASKETS

NEWSPAPER BASKET

WOVEN GROCERY BAG PAPER BASKET

OAKWOOD-COPPER & RETRACTABLE BEAUTY CAN WASTE BASKETS

ROUNDED- & SQUARED EASTER BASKETS

PLAITED BASKET

AMERICAN INDIAN RIVER CANE & STRAW BASKETS

BY: Gregory L. Blackstock

COLORFUL EGG PATTERN FAVORITES TO GO FOR
BY: Gregory L. Blackstock

STAR-SPANGLED EGG	DUTCH BANNER EGG	8-COLOR SPOTTED EGG	GERMAN BANNER EGG	SLIVERED EGG
SERBIAN BANNER EGG	SLANTED DIAMOND CHECKERBOARD EGG	SPANISH BANNER EGG	SQUARE CHECKERBOARD EGG	ETHIOPIA AFRICAN BANNER EGG
16-COLORED CHUNK EGG	BULGARIAN BANNER EGG	POLKA DOT EGG	RUSSIAN BANNER EGG	MULTIPLE-COLORED TEARDROP EGG
HUNGARIAN BANNER EGG	GREEK BANNER EGG	AUSTRIAN BANNER EGG	SWEDISH BANNER EGG	KENYA AFRICAN BANNER EGG
MALAYSIAN BANNER EGG	IRISH BANNER EGG	OUR GREAT AMERICAN NATIONAL BANNER EGG	ITALIAN BANNER EGG	AMERICAN INDIAN DIAMOND CHECKERBOARD EGG
FRENCH BANNER EGG	SQUARE DIAMOND CHECKERBOARD EGG	RUMANIAN BANNER EGG	HONEYCOMB EGG	NIGERIA AFRICAN BANNER EGG
CHINA MAINLAND BANNER EGG	BELGIAN BANNER EGG	TURKISH BANNER EGG	CANADIAN BANNER EGG	BELARUS DIAMOND CHECKERBO. EGG
CZECH BANNER EGG	MACEDONIAN BANNER EGG	FILIPINO BANNER EGG	UNITED KINGDOM'S UNION JACK BANNER EGG	INDONESIAN BANNER EGG
ALGERIA AFRICAN BANNER EGG	THAI BANNER EGG	BRAZILIAN BANNER EGG	SUDAN AFRICAN BANNER EGG	PAKISTANI BANNER EGG
ARGENTINE BANNER EGG	AUSTRALIAN BANNER EGG	INDIA BANNER EGG	FINNISH BANNER EGG	EGYPTIAN BANNER EGG
SOUTH AFRICAN REPUBLIC BANNER EGG	BANGLADESH BANNER EGG	TANZANIA AFRICAN BANNER EGG	JAPANESE BANNER EGG	UKRAINIAN BANNER EGG
ISRAELI BANNER EGG	ZIGZAG EGG	VIETNAMESE BANNER EGG	MULTIPLE-COLORED RAINDROP EGG	MOROCCO AFRICAN BANNER EGG

MORE COLORFUL EGG-PATTERN FAVORITES TO GO FOR

	BOLIVIAN BANNER EGG	OLD ORIGINAL RWANDA AFRICAN BANNER EGG.	U.S. AFRO-AMERICAN COMM
...THE GRENADINES BANNER EGG			
...BANNER EGG	ZAMBIA AFRICAN BANNER-STRIPED EGG	QATAR BANNER EGG	MODERN AFGHAN BANNER-ST
NEW GUINEAN BANNER EGG	UZBEKISTANI BANNER EGG	TRINIDAD & TOBAGO BANNER EGG	SLOVAKIAN BANNER EGG
...RICAN COMMUNITY BANNER EGG.	LIBERIA AFRICAN BANNER EGG	SYRIAN BANNER EGG	NEW ZEALAND BANNER
...NAL HAITIAN BANNER EGG	TAJIKSTANI BANNER EGG	SINGAPORE BANNER EGG	HONDURAS BANNER EGG
...TURKISH CYPRUS BANNER EGG	BENIN AFRICAN BANNER EGG	SURINAM(E) BANNER EGG	UNITED ARAB EMIRATES BAN
...N BANNER EGG	CAMBODIAN BANNER EGG	BURKINA-FASO AFRICAN BANNER EGG	SWAZILAND AFRICAN BANNER EGG
...CAN BANNER EGG	KUWAIT BANNER EGG	PORTUGUESE EUROPEAN 2-COLOR BANNER-SECTIONED EGG	UGANDA AFRICAN BAN
...AY BANNER EGG	SOLOMON ISLANDS BANNER EGG	SÃO TOMÉ & PRÍNCIPE AFRICAN BANNER EGG	LESOTHO AFRICAN BANNER
...AFRICAN BANNER EGG	CUBAN BANNER EGG	JAMAICAN BANNER EGG	VANUATU BANNER EGG
...ISLANDS BANNER EGG	BURMESE BANNER EGG	PUERTO RICAN BANNER EGG	SPECTRUM EGG